THE HARTFORD
WHALERS

On the front cover: Please see page 123. (Photograph by John Clark Russ; courtesy of the Hartford Courant.)

On the back cover: Please see page 123. (Photograph by John Clark Russ; courtesy of the Hartford Courant.)

Cover background: Please see page 30. (Courtesy of the Sports Museum.)

THE HARTFORD WHALERS

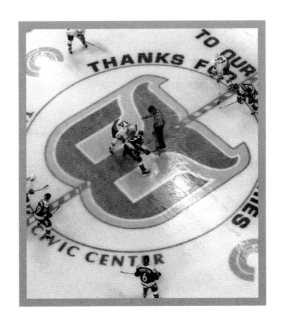

Brian Codagnone

ARCADIA
PUBLISHING

Published by Arcadia Publishing
Charleston SC, Chicago IL, Portsmouth NH, San Francisco CA

Printed in the United States of America

Library of Congress Catalog Card Number: 2007930871

For all general information contact Arcadia Publishing at:
Telephone 843-853-2070
Fax 843-853-0044
E-mail sales@arcadiapublishing.com
For customer service and orders:
Toll-Free 1-888-313-2665

Visit us on the Internet at www.arcadiapublishing.com

Dedicated to all those who still hear "Brass Bonanza."

CONTENTS

FOREWORD

Get ready for a walk down memory lane for all Hartford Whaler fans, whether you were there as the logo went from New England harpoon to the creative whale tail with a *W* and *H* built right in. Any fan that suffered from a roof collapse to the relocation to Raleigh, North Carolina, will get a fun dose of players, stories, and pictures. As a young high school player, I made the trek to Springfield, Massachusetts, a number of winter nights to experience the early Whaler years with my dad, Bill, behind the bench. Whether watching Gordie scare guys half his age or the smooth skating of Mark and defensive prowess of Marty, the Howe family gave the Whalers national recognition.

I remember my first training camp in September 1985 as I started my professional career and having a 20-year-old "veteran," Ron Francis, taking me under his wing. Chemistry: that was the identity of Whaler teams. Emile Francis and Larry Pleau put a team on the ice that could and would play hard and smart through 80 games: Jack Evans, Joel Quenneville, Mike Liut, Ulf Samuelsson, Dave Tippett, Ray Ferraro, Paul MacDermid, Torrie Robertson, John Anderson. What an incredible rise from struggling to make the playoffs to Adams Division winners and earning the respect of Original Six franchises to the east and north. Through these pages you will enjoy the faces, the action photographs, and the stories that made the Hartford Whalers a team with great personality and emotional attachment.

Any Whaler fan who was along for the ride during this period will enjoy Brian's book. He has captured the spirit and will once again make you wish to see the Hartford Civic Center rocking to the sight of green and blue jerseys and the sound of "Brass Bonanza."

—Kevin Dineen

INTRODUCTION

The team that would become the Hartford Whalers began in 1971 when an ambitious group of businessmen decided to form a new league to challenge the monopoly the National Hockey League (NHL) had on major-league hockey. Naming it the World Hockey Association (WHA), the group sought to establish a second major league with franchises across the United States and Canada. In order to accomplish this, the new league lured NHL players with big contracts, more money than many had ever made. The biggest name of all was Chicago's Bobby Hull, whose million-dollar signing bonus and generous long-term contract made headlines and sent shock waves across the sports world. He was followed by such stars as Derek Sanderson, Gerry Cheevers, Bernie Parent, and J. C. Tremblay, among others. In New England, a franchise was awarded to businessmen Howard Baldwin, John Colburn, Godfrey Wood, and William Barnes. Dubbed the Whalers as a tribute to the whaling heritage of the region, the team named Jack Kelley, a highly successful coach at Boston University, as coach and general manager. In addition to Kelley's collegiate coaching success, by naming him coach and general manager the team strove to achieve a true New England flavor. Many Boston-bred players were signed, including Paul Hurley, John Cunniff, Tim Sheehy, and Kevin Ahern.

Massachusetts native Larry Pleau was the first to sign a contract, followed by such NHL players as Al Smith, Brad Selwood, Rick Ley, and Jim Dorey. The biggest star to sign was longtime Bruin favorite Ted Green, originally drafted by Winnipeg, who was named the first captain. Another ex-Bruin and Olympic hero, Tommy "Bomber" Williams also signed and scored the first goal in franchise history in a game against the Philadelphia Blazers before a packed house at the Boston Garden. The ceremonial face-off was between captains Ted Green and former teammate Derek Sanderson, who had also signed a huge contract. Sanderson's stay in the WHA would be short-lived, however. His contract was bought out, and he was back with the Bruins by February. It was symbolic of the WHA's often-precarious existence. In an all too common occurrence over the next seven years, the Blazers soon left Philadelphia in search of solvency and a bigger fan base. New teams were added, but more often others would move or go bankrupt in the league's seven-year existence.

The Whalers had a very successful first season, winning the WHA's first championship. Although their games were well attended, the Whalers were never serious competition for the Bruins. The "Big, Bad Bruins" sold out every game, making tickets virtually impossible to come by; even their minor-league affiliate Boston Braves played to packed houses. Looking for a new home, the Whalers chose Hartford and its new (although as yet unfinished) arena, the Hartford Civic Center. For the 1974 playoffs, they relocated to Springfield, Massachusetts, where they would play until their new home was ready.

On January 11, 1975, the Whalers played their first game in the new Hartford Civic Center before a sellout crowd. Now the number one hockey draw in town, the team enjoyed tremendous

popular support from the Hartford fans. In 1977, the Whalers hosted the WHA All-Star Game and, in the spring of that year, scored one of the major coups in hockey history. Legendary player Gordie Howe had been lured out of retirement to play with his sons Mark and Marty with the WHA's Houston Aeros. Now, as the Aeros were failing, a bidding war began for the services of the Howe family in the WHA and the NHL. The Whalers managed to lure the trio to Hartford.

When a roof collapse forced the Whalers to relocate temporarily to Springfield, loyal fans formed what they called the I-91 Club after the highway between the two cities. Commuting to Springfield, the faithful continued to cheer on their Whalers. Although they would be absent from Connecticut for two years while their home was being rebuilt, they would play the rest of their WHA career as a Hartford club. In 1979, along with Winnipeg, Edmonton, and Quebec, the Whalers join the NHL as "expansion teams" for the 1979–1980 season.

Rechristened the Hartford Whalers and sporting a new logo incorporating a WH whale tail motif, the club featured NHL veterans such as Dave Keon, Bobby Hull, and Gordie Howe (the merger deal allowed players who jumped to the WHA to remain with their new clubs rather than return to their old teams). Although not as successful as they had been in the WHA, because of their Connecticut location, they developed a rivalry with both the Boston Bruins and the New York Rangers. And the fans supported them even more than they had as a member of the WHA; while the WHA was a major professional league, the NHL was the big time. Hartford had arrived.

Many memorable and popular players including Ron Francis, Kevin Dineen, Ray Ferraro, Ulf Samuelsson, Sylvain Turgeon, Geoff Sanderson, Pat Verbeek, Keith Primeau, Mike Liut, and Chris Pronger wore the Whalers' colors in the NHL. Doug Jarvis broke Gary Unger's "iron man" record in a Whalers uniform. Although playoff success seemed to elude them, in 1986 they won the Adams Division championship. While they were knocked out of the playoffs by the Quebec Nordiques, the fans of Hartford still threw their beloved team a parade. Ray Ferraro summed up the relationship with the city and fans of Hartford this way: "I felt that it was a special time for a lot of us. We were treated so well in Hartford, it was a great place to be. I have my first NHL goal, the 1986 playoffs and many great teammates and friends that I am lucky enough to have in my mind as memories of my time with the Whalers." It is a feeling shared by many players. Once a Whaler, always a Whaler.

ACKNOWLEDGMENTS

I would like to thank the following people for their contributions in the creation of this book: Howard Baldwin, John Bishop, Matt Brady, Will Brother, Laura Brubaker, Barry Corbett, Skip Cunningham, Kevin Dineen, Ray Ferraro, Nate Greenberg, Craig Hansen, Howard Hewitt, Carleton McDiarmid, Harvey McKenney, Tim Sheehy, Paul Stewart, Alan Thibeault, photographers Mike Andersen, Steve Babineau, Tim Killorin, and Al Ruelle, and, of course, the gang at the Sports Museum: Michelle Gormley, Dick Johnson, Rusty Sullivan, and the late Gordon Katz.

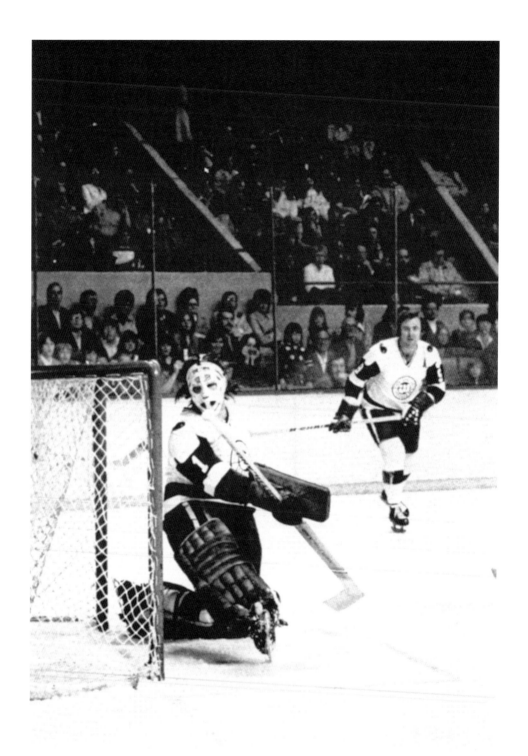

A WHALE OF A TIME. Al Smith (left) and Tommy Williams, two of the most colorful players on a colorful team, were among many that jumped the NHL to play in the new WHA. (Courtesy of the Sports Museum.)

1

ORIGINS

The National Hockey League (NHL) was the major hockey league in North America and had been since 1917. Others, such as the American Hockey League (AHL) and the Pacific Coast Hockey League, played a big-league brand of hockey with their own heroes, legends, career players, long-lived teams, and loyal fans but were still minor leagues. Only the NHL was the big time. In 1967, the NHL made what was the most radical expansion in professional sports, doubling its size. By 1971, the Original Six had become 14, but there were those who felt that another major league could survive. Gary Davidson and Dennis Murphy, two entrepreneurs who had been involved with the American Basketball Association, hatched a plan to create the World Hockey Association (WHA) to break the NHL's monopoly on major-league hockey. In 1971, the WHA came into being, on paper anyway. The business of establishing franchises began. New England was a hotbed of hockey, and Howard Baldwin knew that a WHA franchise could make it in Boston. In typical WHA fashion, he had no money and had never run a team but managed to put together a group that included John Colburn, Godfrey Wood, and William Barnes to create the New England Whalers. One reason for the Whalers' success was the financial support of Celtics owner Bob Schmertz, which Baldwin arranged. With his financial backing, the Whalers were ready to do all the things a new team needed to do: hire a coach, sign players, and buy equipment. By the fall of 1972, the new team in the new league was ready to play. The dream had become a reality.

HOWARD BALDWIN. Although part of an ownership group that included John Colburn, Godfrey Wood, and William Barnes, Howard Baldwin was the driving force behind the Whalers. While serving as president of the WHA, Baldwin helped negotiate the merger of the WHA with the NHL, and as a member of the NHL Board of Governors, he continued to head up the franchise until it was sold. (Courtesy of the Sports Museum.)

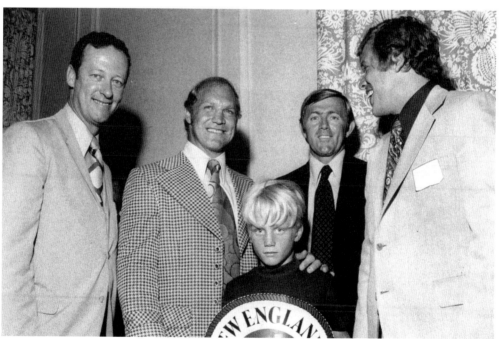

LEGITIMACY. The WHA needed an NHL superstar to solidify its position as well as attract players. The league combined its assets to pay Bobby Hull a then-unheard of sum of $1 million (signing bonus) and $250,000 a year for five years. From left to right are Bill Barnes, Bobby Hull, Gary Davidson, and Howard Baldwin. The boy is Hull's son Brett, who went on to be a pretty good player in his own right. (Courtesy of the Boston Herald.)

JACK KELLEY. Legendary college coach Jack Kelley became the first coach and general manger of the Whalers. Much of the success of the team can be attributed to Kelley, who used his knowledge of college, junior, and minor-league players to stock the team. He was especially successful scouting local talent, signing such Massachusetts players as Paul Hurley, John Cunniff, Tim Sheehy, and Kevin Ahern. (Courtesy of the Sports Museum.)

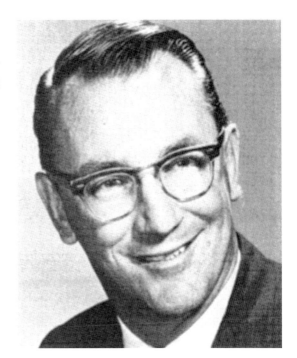

FROM COLLEGE TO THE PROS. Although he had been given offers to coach professionally, Jack Kelley had always declined. He made the jump from the collegiate ranks to the pros with the Whalers, serving as both coach and general manager. His Whalers won the first Avco World Cup, and he was named Coach of the Year. (Cartoon by Bob Robertson, courtesy of the Sports Museum.)

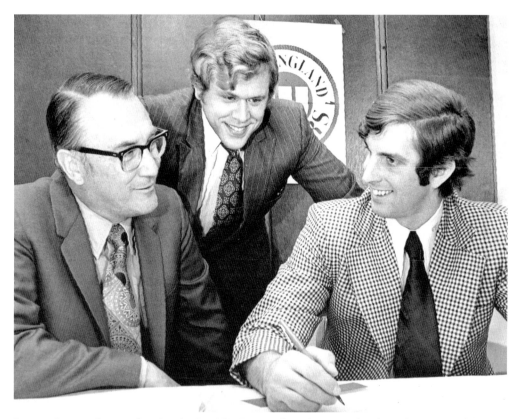

LARRY PLEAU SIGNS. On April 19, 1972, Larry Pleau became the first player signed by the Whalers. Jack Kelley (left) and Howard Baldwin look on as Pleau puts his name to a three-year deal. (Courtesy of the Boston Herald.)

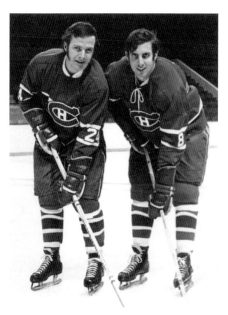

TWO THAT GOT AWAY. Massachusetts hockey stars Bobby Sheehan (left) of Weymouth and Larry Pleau of Lynn both played in the Montreal Canadiens organization. Although Sheehan got more ice time with the Habs, he too would jump to the WHA. (Photograph by Al Ruelle.)

TED GREEN. "Terrible Ted" Green had been a bone-crunching defenseman with the Bruins since the early 1960s. In the fall of 1969, he survived a near-fatal skull fracture in an exhibition game stick fight. He missed the entire 1969–1970 season, when the Bruins won the Stanley Cup for the first time in 29 years. After extensive physical therapy, Green returned to the Boston lineup and was a member of the 1972 Stanley Cup squad. (Courtesy of the Sports Museum.)

TED GREEN IN REHAB. As the result of a brutal stick fight with Wayne Maki of the St. Louis Blues, Ted Green had to overcome brain damage and partial paralysis and learn to shoot from his opposite hand in order to return to hockey. (Photograph by Al Ruelle.)

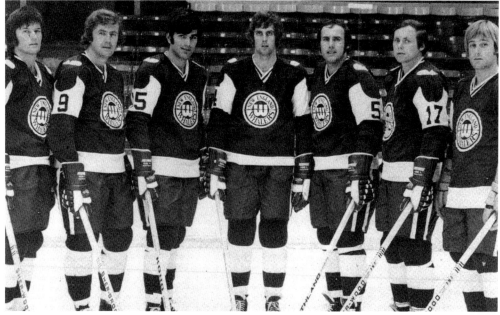

KELLEY'S HEROES. American-born and collegiate players made up much of the Whalers' first roster. This group included (from left to right) Kevin Ahern, Tommy Williams, Tim Sheehy, Larry Pleau, Paul Hurley, John Cunniff, and Toot Cahoon. (Photograph by Tim Killorin.)

JOHN CUNNIFF. Local hero John Cunniff was an original Whaler. The Boston College star played on the U.S. national and U.S. Olympic teams before turning professional. He would play 63 games in green over two seasons and later coach the team when it joined the NHL. His coaching career included stints in New Jersey and Boston in the NHL and Binghamton and Albany of the AHL. (Photograph by Tim Killorin.)

FROM BLUE AND WHITE TO GREEN AND WHITE. Seen here, from left to right, Brad Selwood, Rick Ley, and Jim Dorey all played for the Toronto Maple Leafs before jumping to the WHA. In addition to the money, many players were unhappy with the Leafs ownership under Harold Ballard. Several Leafs would defect, but the biggest name was captain Dave Keon. After stops in Minnesota and Indianapolis, Keon would end his career with the Whalers. (Photograph by Tim Killorin.)

TIM SHEEHY. Another one of Jack Kelley's Americans, Boston College star Tim Sheehy scored 33 goals in the Whalers' first season. Traded to Edmonton in 1975, he saw service with the Birmingham Bulls and Detroit Red Wings before returning to play with the Whalers in the WHA and NHL. (Photograph by Tim Killorin.)

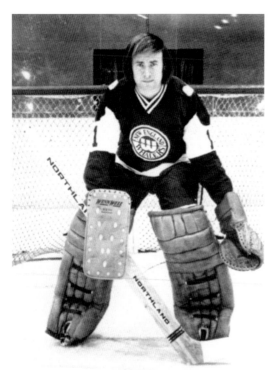

AL SMITH. An NHL journeyman goaltender, Al Smith backstopped the Whalers to the first WHA championship in 1973. He was the ultimate free spirit. After retiring from goaltending, he became a writer and Toronto cab driver before succumbing to a tumor of the pancreas at the young age of 56. (Photograph by Tim Killorin.)

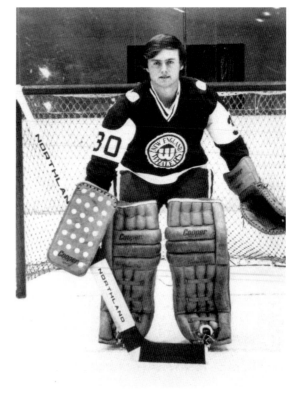

BRUCE LANDON. Bruce Landon served as Al Smith's backup on the Whalers' first team, playing in 26 games. Landon played five years with the Whalers, mostly in the role as a steady and reliable backup. After he retired, Landon became the co-owner of the Springfield Falcons of the AHL. (Photograph by Tim Killorin.)

Tommy Williams. Tommy "Bomber" Williams graces the cover of the Whalers' fan magazine (titled, what else, the *Harpoon*). The Minnesota native and Olympic star was one of the few American players in the pre-expansion NHL, having played for Boston. After the 1967 expansion, he also played for Minnesota and California before jumping to the new league. He was typical of many of the league's early players, talented but unable to crack the six-team league. And like a lot of the players he was colorful and played the game with a true passion. (Right, author's collection; below, photograph by Tim Killorin.)

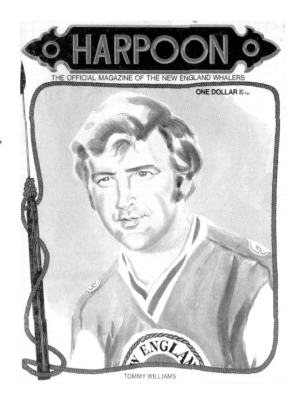

TOMMY WILLIAMS

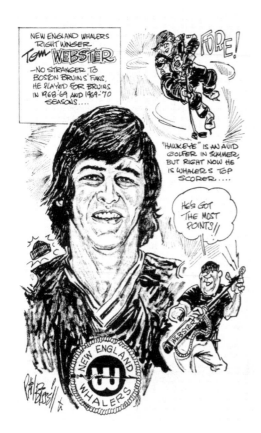

TOM WEBSTER. In the six-team era there were more talented players than there were jobs. Tom "Hawkeye" Webster was a typical case—a hard-skating journeyman who found his place in the new league. The white skates were courtesy of his previous team, the California Golden Seals. (Left, cartoon by Phil Bissell; below, photograph by Tim Killorin.)

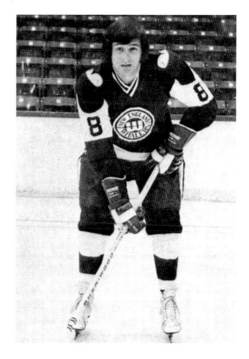

Boston

DECEMBER 1972 75¢ MAGAZINE

Can the Whalers Harpoon the Bruins?

How the Mafia Can Take Over Your Business

The 45 Most Extravagant Gifts in Town

CAN THE WHALERS HARPOON THE BRUINS? A harpoon-toting Jim Dorey glares menacingly from the December 1972 cover of *Boston Magazine*. While the upstart Whalers played in the Boston Garden and featured such hometown favorites as former Bruin Ted Green, the supremacy of the Bruins was never in doubt. The reigning Stanley Cup champions sold out every game while the fledgling WHA tried to establish itself as a second major league. (Author's collection.)

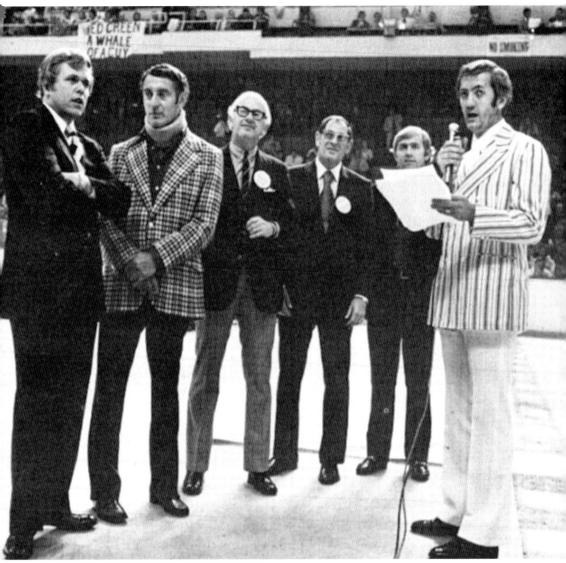

OPENING NIGHT, OCTOBER 12, 1972. From left to right are Howard Baldwin, president of the New England Whalers; Bob Schmertz, chairman of the Whalers; Jim Cooper and Bernie Brown, president and chairman of the Blazers; Gary Davidson, president of the WHA; and Art Dunphy, the Whalers' director of public relations. It took a lot of effort, a lot of faith, and a lot of just plain chutzpah, but the new league was finally off the ground. In addition to an assortment of minor leaguers, castoffs, and collegians, some 60 NHL players jumped to the new league. It was the opening night for the Whalers but not the WHA. The night before the Quebec Nordiques faced the Crusaders in Cleveland, and the Alberta Oilers traveled to Ottawa to take on the Nationals. (Courtesy of the Sports Museum.)

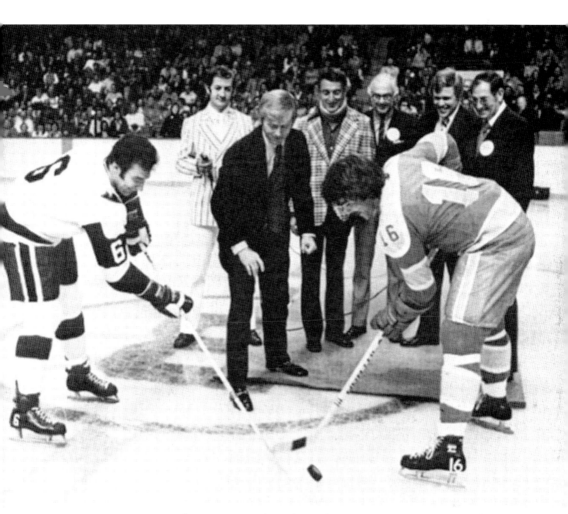

OPENING NIGHT. WHA president Gary Davidson drops the puck between captains Ted Green and Derek Sanderson as the Whalers host the Philadelphia Blazers at Boston Garden. Captained by ex-Bruin Derek Sanderson, the Blazers started life as the Miami Screaming Eagles but never played a game there. Moving to Philadelphia and renamed the Blazers, they hoped to steal some of the Flyers' fan base. Other NHL stars on the club included former Bruin and future Whaler Johnny "Pie" McKenzie, future Whaler Andre Lacroix, and All-Star goaltender (and former Flyer) Bernie Parent. Their stay in Philadelphia would be brief, however. They moved to Vancouver in May 1973. Sanderson's stay would be even more fleeting, playing just eight games before the Blazers bought out his 10-year, $2.35 million contract. He would return to wearing black and gold before the season was over. (Courtesy of the Sports Museum.)

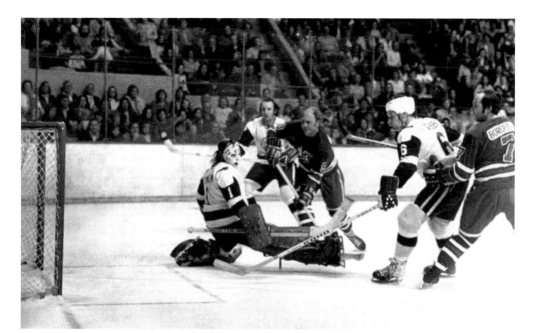

BOBBY HULL SCORES ON AL SMITH. Bobby Hull, the Golden Jet, puts one past Al Smith as Paul Hurley, Ted Green, and Christian Bordeleau look on. (Courtesy of the Sports Museum.)

ACTION AGAINST NEW YORK. John French takes on Hal Willis of the New York Raiders, another original member of the WHA. The Raiders would become the New York Golden Blades, then move to New Jersey, becoming the Jersey Knights and later the San Diego Mariners. (Courtesy of the Sports Museum.)

THE MINNESOTA FIGHTING SAINTS. In this rare photograph sequence, Tom Webster is trying to get the puck past a sprawling Carl Wetzel while Bob MacMillan, Terry Ball, Rick Smith, and Don Blackburn look on. An unusual feature of the St. Paul Civic Center was the clear Plexiglas boards. One will also notice that they are not exactly playing to a full house. This team was the first version of the Fighting Saints, who would fold, be reborn, and fold again. One of the more colorful teams in the WHA, Minnesota included such players as Mike Walton, Dave Keon Johnny McKenzie, and the Carlson brothers, Jack, Jeff, and Steve. Jeff and Steve, along with Dave Hanson, would go on to fame as the Hanson brothers in the movie *Slapshot* (Jack got called up before filming). Jack and Steve would later play for the Whalers. Another minor-league legend who had a brief stint with the Saints was Goldie Goldthorpe, the real-life model for *Slapshot*'s Ogie Oglethorpe (Photographs by Tim Killorin.)

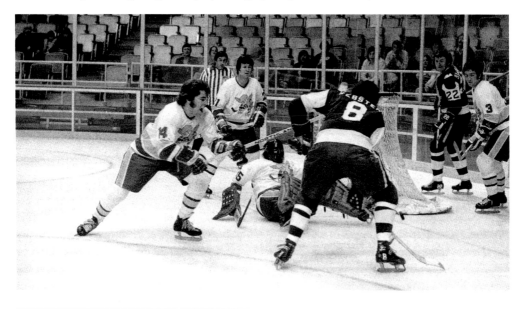

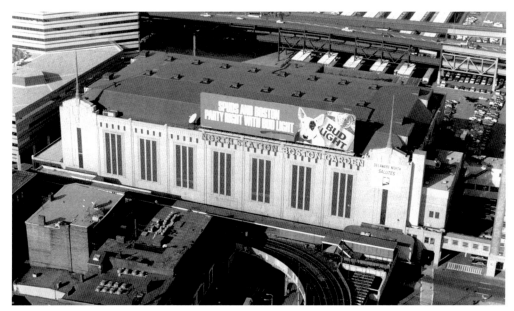

BOSTON GARDEN. The Whalers played in the Boston Garden and Boston Arena during their time in Boston. Because the Bruins (not to mention the AHL Braves), Celtics, and concerts had first pick of dates, the Whalers often found themselves the odd man out when it came to scheduling. (Courtesy of the Sports Museum.)

BOSTON ARENA. The Whalers played many games at the old Boston Arena (now Northeastern University's Matthews Arena), mostly when the Boston Garden was occupied. The oldest indoor ice rink in the United States, it predated the Boston Garden and was the original home of the Bruins. By the 1970s, it was badly outdated and too small to hold the crowds the Whalers needed to make a profit. (Courtesy of Howard Hewitt.)

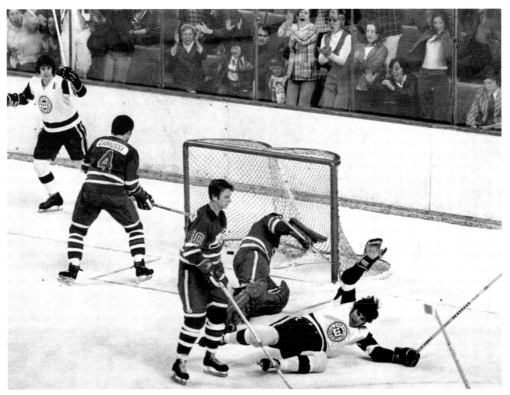

THE WHALERS IN ACTION AGAINST WINNIPEG. Although the Whalers won the first Avco Cup in 1973, the Jets would win three during the league's existence seven year existence, including the final one in 1979. (Courtesy of the Sports Museum.)

AL SMITH STOPS ONE. Concerned teammates gather around as the trainer attends to fallen goalie Al Smith. Note the unusual uniform on the official. Like many "rival" leagues, the WHA experimented with brightly attired officials and even colored pucks. Luckily neither caught on. (Photograph by Tim Killorin.)

WATCHING THE GAME GO BY. Jean Gauthier of the New York Raiders and Larry Pleau get left behind as play moves up the ice. (Courtesy of the Sports Museum.)

STALWARTS OF THE DEFENSE. Brad Selwood eases Philadelphia Blazers captain Derek Sanderson out of the crease as Jim Dorey gives his man a close-up view of the net. (Photograph by Tim Killorin.)

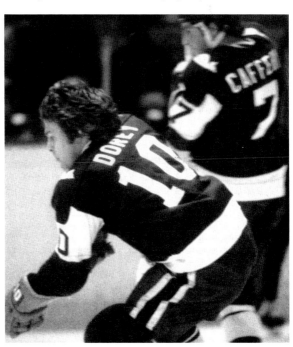

JIM DOREY AND TERRY CAFFERY. Terry Caffery was the WHA's first Rookie of the Year and one of seven players to score 100 points (teammate Tom Webster scored 103). Playing on a line with Webster and Brit Selby, he suffered a knee injury in the 1973 playoffs. Although he came back after missing the following season, the injury eventually cut short what might have been a hall-of-fame career. (Courtesy of the Sports Museum.)

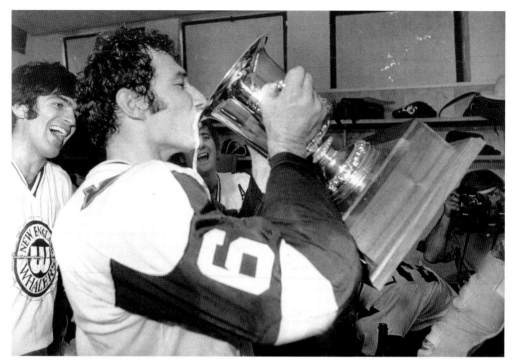

THE FRUITS OF VICTORY. Captain Ted Green celebrates the 1973 Avco World Cup as the Whalers become the first champions in WHA history. (Photograph by Mike Andersen.)

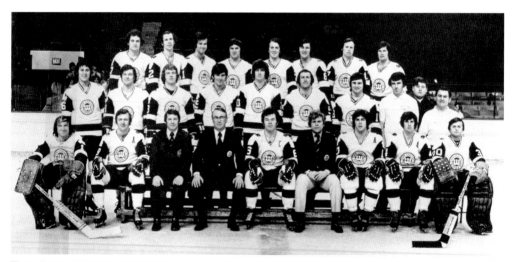

THE AVCO WORLD CUP CHAMPIONS. Pictured, from left to right, are (first row) Al Smith, Tommy Williams, assistant coach Ron Ryan, coach and general manger Jack Kelley, captain Ted Green, team president Howard Baldwin, Jim Dorey, Larry Pleau, and Bruce Landon; (second row) Guy Smith, Mike Byers, Brad Selwood, Tim Sheehy, Ric Jordan, Paul Hurley, Brit Selby, equipment manager Skip Cunningham, stick boy Howie Hewitt, and trainer Joe Altott; (third row) Tom Earl, John Danby, John French, Rick Ley, Terry Caffery, Tom Webster, John Cunniff, and Kevin Ahern. (Courtesy of the Sports Museum.)

2

HARTFORD

In the early 1970s, Boston was home to three professional hockey teams, the Bruins of the NHL, the Whalers of the WHA, and the Braves of the AHL. Plenty of hockey to go around, to be sure, but the problem was where to play it all. The Whalers were splitting their time between the Boston Garden, where they ranked behind the Bruins, Celtics, and Braves for precious schedule time, and the antiquated Boston Arena across town. The original home of the Bruins in 1924 and the world's oldest indoor ice rink, the arena was too old and too small by the 1970s. By their second season, the Whalers realized that a relocation was necessary, somewhere in New England where they would be the number one team. The choice to stay in New England was motivated by both a loyalty to the region and also to avoid the stigma of failure that automatically surrounded teams that could not make it and had to move on to greener pastures. The WHA had no shortage of those, unfortunately, but the Whalers would be different. They would move to a new city, but they would still be the New England Whalers. The city of Hartford, Connecticut, was eager to have the team. Best known as the insurance capital of America, Hartford felt that having a major-league franchise would be a boon to the city in both pride and revenue. Due to the efforts of a dedicated group called the Downtown Council, lead by Howard Baldwin and Donald Conrad, the dream became a reality. However, while Hartford rolled out the red carpet, there was one looming problem. The brand-new Hartford Civic Center, the Whalers' new downtown home, would not be ready until January 1975. Until then, the Whalers opted to continue playing in the Eastern States Coliseum in West Springfield, where they had moved to for the 1974 playoffs. They played 13 "home" games at the "Big E" before the grand opening of the civic center on January 11, 1975. It was, in the words of Humphrey Bogart in *Casablanca*, "the beginning of a beautiful friendship," one that would live on well beyond the team's departure in 1997.

THE HARTFORD SKYLINE. The city known for insurance and Mark Twain would now be known as the home of the Whalers. (Courtesy of Michael Czaczkes.)

THE HARTFORD CIVIC CENTER. Although it was not complete when the Whalers left Boston, the civic center served as their home for most of the team's existence. Originally located adjacent to a shopping mall, which was demolished in 2004, it was originally built in 1975 and was rebuilt after a roof collapse in 1978. (Courtesy of the Hartford Civic Center.)

The Boston Globe

Sports Plus

Also Inside:

Checking John McKenzie

Sizing up Ken Stabler

Shaping Up for the Slopes

Right Wing John McKenzie

The Whalers
Sinking ... or a Success?

VOL. 3, NO. 24 — FRIDAY, DECEMBER 8, 1978

A NEW LIFE. Now out of the Bruins' shadow and with strong fan support in Hartford, the Whalers were definitely a success. (Courtesy of the Sports Museum.)

FEELIN' GROOVY ABOUT THE 1973–1974 SEASON. A swirl of 1970s graphics graces the cover of *Faceoff*, the official magazine of the WHA. (Courtesy of the Sports Museum.)

ANDRE LACROIX. Small but with a scoring touch, Andre Lacroix started his NHL career with the Flyers. After a brief stay in Chicago he joined the WHA, where he had his most productive scoring years. He played for the Whalers in their last WHA and first NHL seasons. Lacroix is the WHA's all-time scoring leader. (Courtesy of the Sports Museum.)

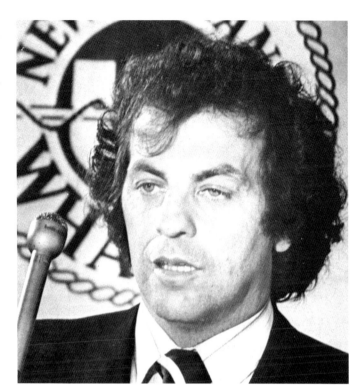

Fred O'Donnell; Try Us . . . You Might Like Us!

Signed:
Phil Maloney
General Manager
Vancouver Canucks
Hockey Club

TRY US . . . YOU MIGHT LIKE US! After a trade from one of the best teams in the NHL, the Boston Bruins, to one of the weakest, the expansion Vancouver Canucks, in October 1974, Fred O'Donnell refused to report to his new team. Canucks management attempted to woo him with this advertisement that ran in the Boston newspapers, but he jumped the NHL for the WHA. He played two seasons in Hartford. (Author's collection.)

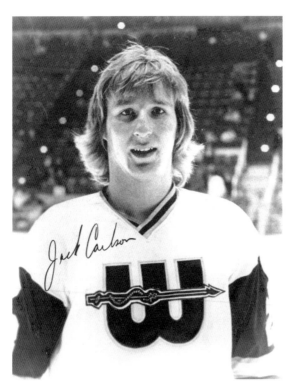

JACK CARLSON. Jack Carlson, the "Big Bopper," was reputed to be one of the best fighters in hockey. He was playing for the Johnstown Jets when he was called up to the Minnesota Fighting Saints. Because of this, he missed the opportunity to play one of the Hanson brothers, along with siblings Jeff and Steve, in the movie *Slapshot*. He was replaced by teammate Dave Hanson. His brother Steve also played for the Whalers. (Courtesy of Matt Brady.)

WAYNE CARLETON. Wayne "Swoop" Carleton played on the Bruins' 1970 Stanley Cup team before being claimed by the Golden Seals, where he played a season before jumping to the WHA. He played 108 games for the Whalers before being traded to Edmonton. A bit of hockey trivia: he was on the ice when Bobby Orr scored his famous goal and is the thigh seen in the corner of the photograph of Orr flying through the air. (Photograph by Tim Killorin.)

OLD-TIME HOCKEY. Rick Ley takes a hard hit from Curt Brackenbury in a game against the Minnesota Fighting Saints. (Photograph by Tim Killorin.)

THE WHALERS TAKE ON THE CINCINNATI STINGERS. Wayne Carleton (No. 9) and Tommy Earl (No. 27) take on Jacques Locas (No. 11) and Serge Autry (No. 35) of the Cincinnati Stingers. (Photograph by Tim Killorin.)

5th
ANNUAL

ALL - STAR
GAME

EAST DIVISION vs. WEST DIVISION

OFFICIAL
PROGRAM
$2.00 (Tax. Incl.)

THE 1997 ALL-STAR GAME. On January 18, 1977, the Whalers hosted the WHA All-Star Game at the civic center. Rick Ley, Gordie Roberts, and George Lyle represented the hometown team, while other stars included Gordie Howe of Houston, Bobby Hull of Winnipeg, Andre Lacroix of San Diego, J. C. Tremblay of Quebec, and Pat Stapleton of Indianapolis. The East Division won 4-2. (Courtesy of Skip Cunningham.)

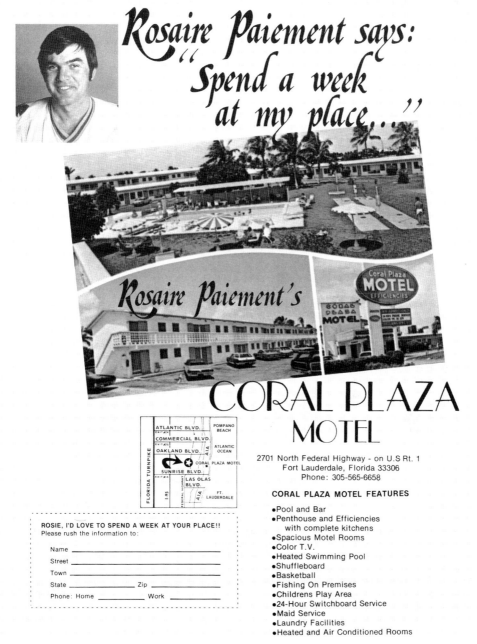

Rosaire Paiement says:
"Spend a week at my place..."

Rosaire Paiement's

Coral Plaza
MOTEL
EFFICIENCIES

CORAL PLAZA
MOTEL

2701 North Federal Highway - on U.S Rt. 1
Fort Lauderdale, Florida 33306
Phone: 305-565-6658

CORAL PLAZA MOTEL FEATURES

- Pool and Bar
- Penthouse and Efficiencies
 with complete kitchens
- Spacious Motel Rooms
- Color T.V.
- Heated Swimming Pool
- Shuffleboard
- Basketball
- Fishing On Premises
- Childrens Play Area
- 24-Hour Switchboard Service
- Maid Service
- Laundry Facilities
- Heated and Air Conditioned Rooms

ROSIE, I'D LOVE TO SPEND A WEEK AT YOUR PLACE!!
Please rush the information to:

Name _____
Street _____
Town _____
State _____ Zip _____
Phone: Home _____ Work _____

COME STAY AT ROSIE'S PLACE! Like many players, Rosie Paiement had outside business interests. The Coral Plaza Motel was the perfect place to get away from a cold New England winter, but in the days before cable, guests could not get Whalers games on the color television in their air-conditioned room. (Courtesy of Skip Cunningham.)

WORLD HOCKEY ASSOCIATION

$2.00

THE INTERNATIONAL SERIES. In 1978, the WHA played a series of exhibition games against the Soviet National Team and star goaltender Vladislav Tretiak, seen here. Games were scheduled against Edmonton, Winnipeg, Quebec, Cincinnati, Indianapolis, and New England. (Courtesy of Skip Cunningham.)

THE WHALERS TAKE ON THE SOVIETS. Gordie Howe watches Soviet goaltender Vladislav Tretiak make a save in an exhibition game held on January 11, 1978. Tretiak, the goalie who stymied team Canada in the 1972 Summit Series, faced the NHL's best, but players who had jumped to the WHA, most notably Bobby Hull and Gerry Cheevers, were excluded. The Soviets won the exhibition game 7-4. (Courtesy of the Sports Museum.)

AL SMITH RETURNS. Original Whaler Al Smith left the team after three seasons to play for the Buffalo Sabres of the NHL. After seeing limited play, he returned to the Whalers in 1975, finishing his career with the Colorado Rockies in 1981. (Courtesy of Skip Cunningham.)

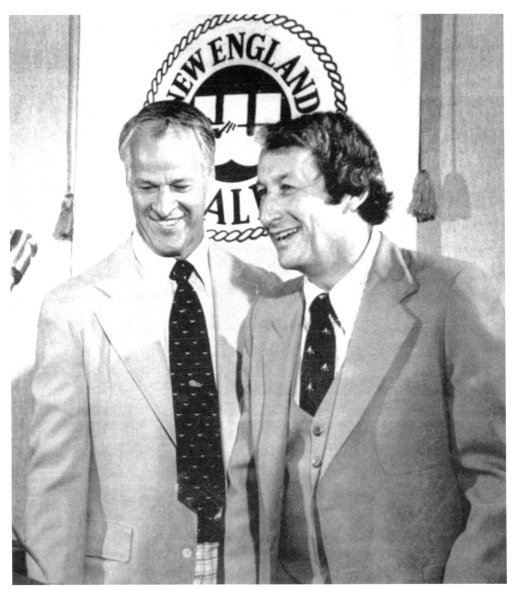

MEET THE NEW COACH. Gordie Howe introduces new coach Bill Dineen at a July 13, 1978, press conference. The former head coach, general manager, and vice president for hockey operations for the Houston Aeros, Dineen became available after the Aeros ceased operations, and the Whalers jumped at the chance to have him behind the bench. Although his coaching tenure was short, his influence on the club was not. As director of player personnel, he was influential in shaping the Whaler teams of the 1980s, including such future stars as Ulf Samuelsson, Ray Ferraro, and his son, Kevin Dineen. (Courtesy of the Boston Herald.)

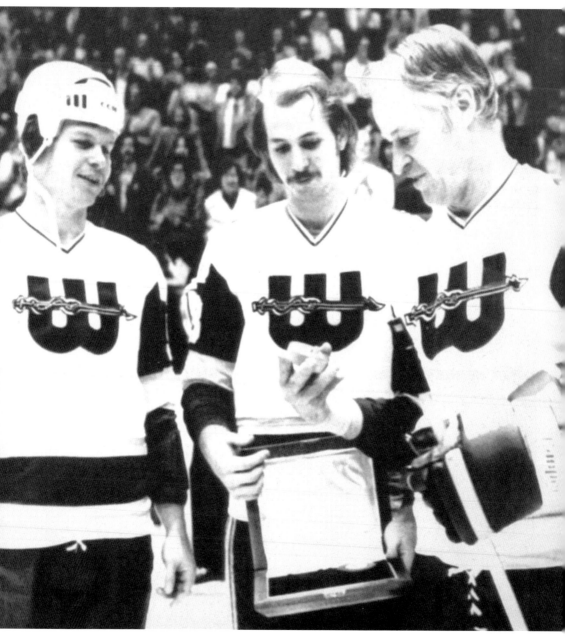

ONE THOUSAND GOALS. Gordie Howe admires a gold puck presented to him in honor of his 1,000th goal. Having scored the goal against the Bulls in Birmingham on December 7, 1977, the puck was presented to the elder Howe by his sons Mark (left) and Marty (center) in a ceremony back home. One of the greatest players in NHL history, Gordie had come out of retirement to play with his sons for the Houston Aeros. After the Aeros folded, all three joined the Whalers. Gordie played with the team until he retired for good in 1980. Marty played for Hartford and Boston, and Mark would go on to enjoy a stellar career with Hartford, Philadelphia, and Detroit. (Courtesy of the Sports Museum.)

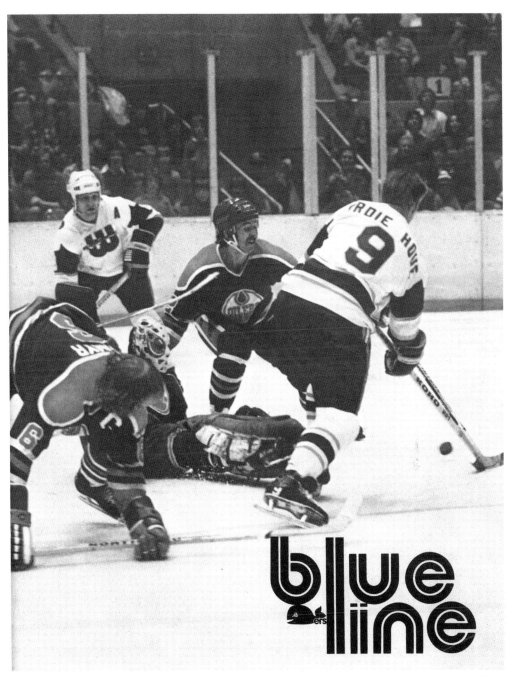

THE BLUE LINE. Gordie Howe is shown in action against the Edmonton Oilers. Both teams, along with Quebec and Winnipeg, would later merge with the NHL. (Courtesy of Skip Cunningham.)

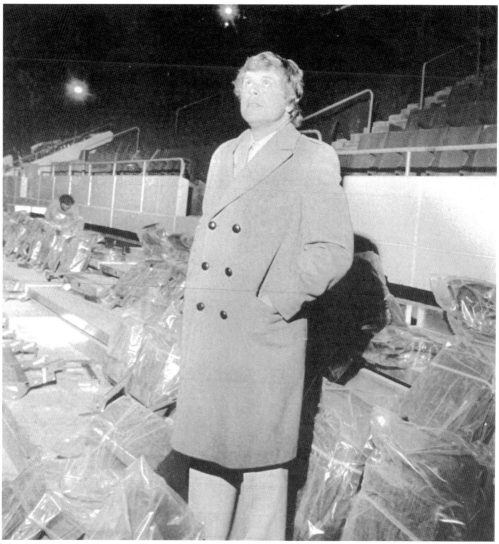

COLLAPSE. At 4:30 a.m. on January 18, 1978, under the weight of snow and ice, the roof of the Hartford Civic Center collapsed. Luckily no one was injured, but the team was forced to relocate temporarily to Springfield. The Whalers would finally return to Hartford on February 6, 1980, now the Hartford Whalers of the NHL. Howard Baldwin surveys the work being done in the arena in January of that year in anticipations of the team's return home. (Courtesy of the Sports Museum.)

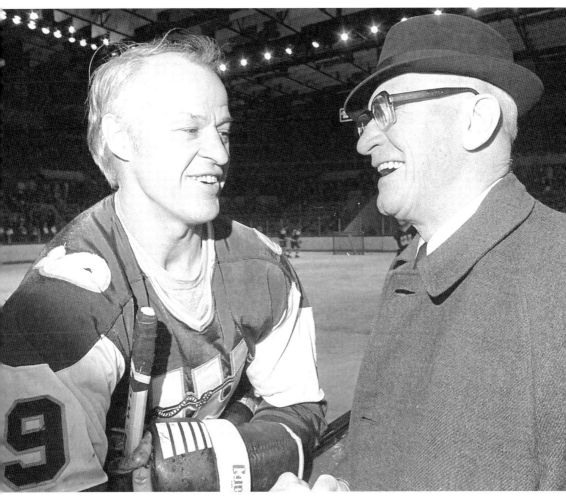

GORDIE HOWE AND EDDIE SHORE. Two of the toughest players to ever lace on skates, Gordie Howe (left) and Eddie Shore chat at the Springfield Civic Center. No strangers to Springfield, the Whalers played there before the Hartford Civic Center was completed. Now they were playing there following the collapse of the arena's roof. Stories about Eddie Shore's toughness are legendary—how he drove from Boston to Montreal through a blizzard after missing a train and despite frostbite and exhaustion scored the winning goal; how after having his ear nearly severed in practice he walked the streets around the Boston Garden until he could find a doctor to sew it back on; how he took over 900 stitches, lost all his teeth, and suffered several broken bones. But in Springfield he was known as the autocratic owner of the Indians. After retiring from hockey, Shore purchased the team, which he ran with an iron fist and not a little eccentricity. Players dreaded being sent there as he not only tried to control every aspect of their game but also was notoriously cheap. In addition to low pay and old equipment, he had players who were not dressed perform chores such as inflate balloons, paint chairs, and so on. (Photograph by Mark Murray, courtesy of the Springfield Republican.)

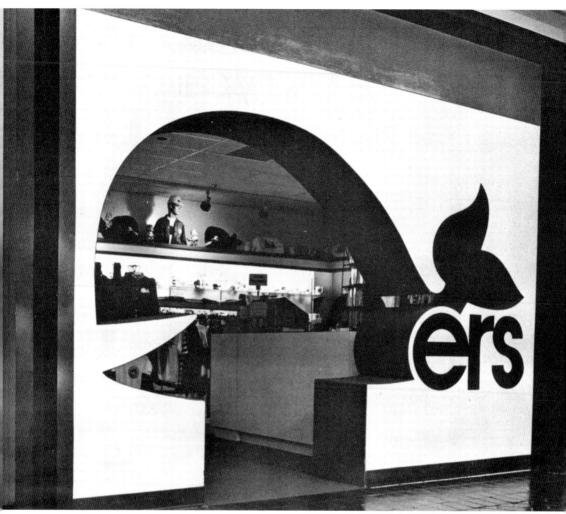

TAKE A WALK THROUGH THE WHALE. Although it may have given Jonah flashbacks, advertisements for the Whalers gift shop promised, "Take a Walk through The Whale and Put a Smile on Your Face!" Located on the second level of the Hartford Civic Center, the Whalers shop had what was undoubtedly the most unique entryway in sports. (Courtesy of Skip Cunningham.)

3

THE NHL

While the WHA sought to establish itself as a second major hockey league, negotiations for a merger with the NHL had been going on for some time. Originally the NHL had scoffed at such a notion, instead opting to wait until the new league failed and became a footnote in hockey history. While the WHA's survival was always precarious and teams came and went, the league managed to survive and, in some markets, thrive. By the late 1970s, a merger seemed a viable option for both leagues. For the NHL, it was expansion into proven territories; for the WHA, it meant solvency in the senior league. Beginning with the 1979–1980 season, four teams, the New England Whalers, Edmonton Oilers, Quebec Nordiques, and Winnipeg Jets, joined the NHL. No longer regional, the Whalers became the Hartford Whalers. Eventually the Jets would move to Phoenix, the Nordiques to Colorado, and the Whalers to North Carolina, leaving the Oilers the only WHA team still in its original city.

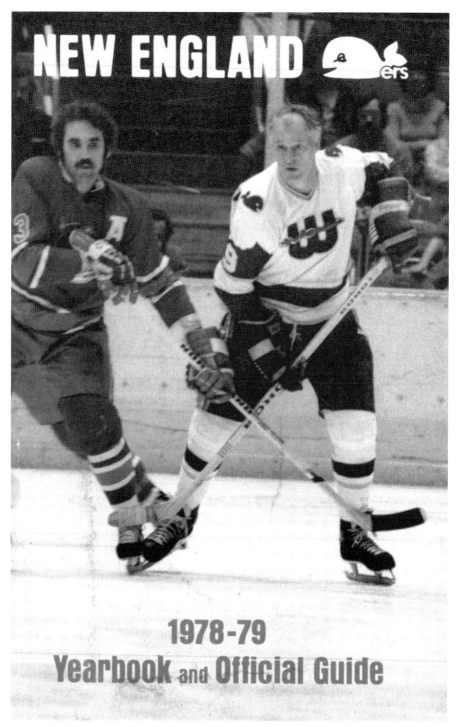

NEW ENGLAND 🐋ers

1978-79
Yearbook and Official Guide

THE LAST WHA MEDIA GUIDE. Elder statesman Gordie Howe takes on the Birmingham Bulls. The next season the Whalers would be in a new league, with a new logo and new colors. (Courtesy of Skip Cunningham.)

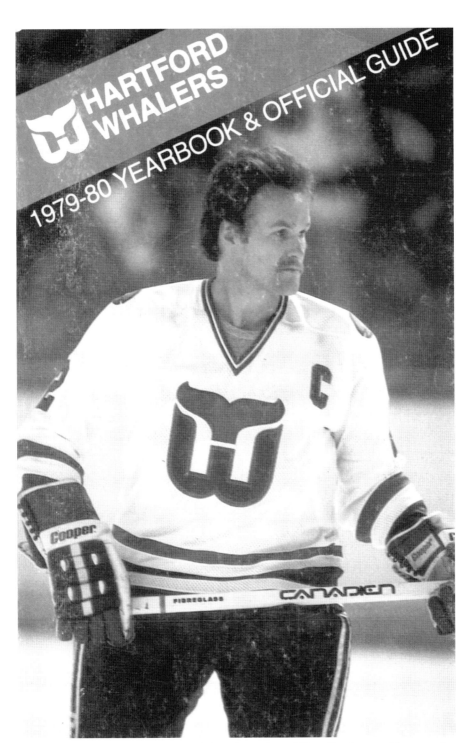

THE LAST ORIGINAL WHALER. Others, like Al Smith and Tim Sheehy, would return, but only captain Rick Ley was still with the team when it moved from the WHA to the NHL. He would finish his career with the Whalers in 1981. (Courtesy of the Sports Museum.)

GORDIE HOWE, BOBBY HULL, AND DAVE KEON. With 74 seasons between them, Gordie Howe (left), Bobby Hull (center), and Dave Keon had enjoyed long NHL careers before jumping to the WHA. Now back in the NHL, the merger deal allowed them to remain in Hartford rather than rejoin their old teams. All three would finish their careers with the Whalers and all three would eventually be inducted into the Hockey Hall of Fame. (Courtesy of the Sports Museum.)

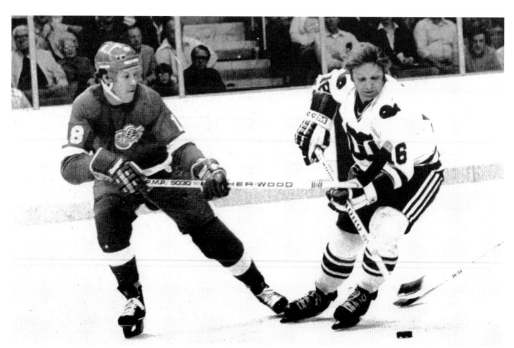

BOBBY HULL. The first big name lured by WHA money, Bobby Hull (right) found himself back in the old league but in a new uniform. (Courtesy of the Sports Museum.)

THE NHL

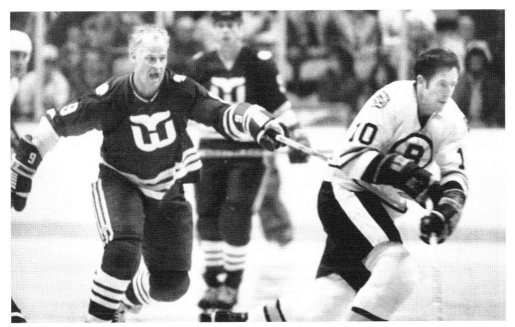

NOT BAD FOR AN OLD GUY. Seen here, 51-year-old Gordie Howe hooks young buck Jean Ratelle, a mere 39. Howe had the distinction of being the only active duty player who was also a grandfather. (Photograph by Mike Andersen.)

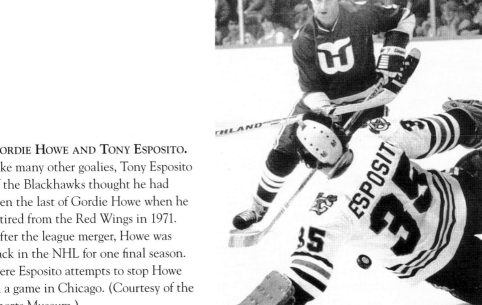

GORDIE HOWE AND TONY ESPOSITO. Like many other goalies, Tony Esposito of the Blackhawks thought he had seen the last of Gordie Howe when he retired from the Red Wings in 1971. After the league merger, Howe was back in the NHL for one final season. Here Esposito attempts to stop Howe in a game in Chicago. (Courtesy of the Sports Museum.)

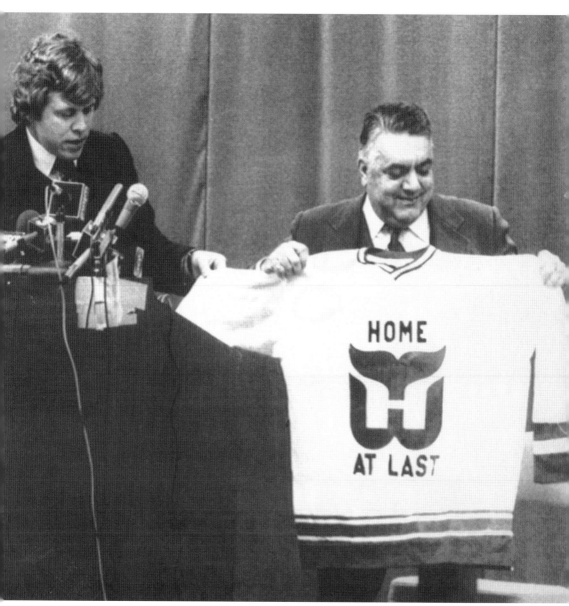

HOME AT LAST. Howard Baldwin looks on as Hartford mayor George Athanson holds up a Whalers jersey emblazoned with the words Home at Last. The occasion was a press conference to announce that the team would soon move back to Hartford and the newly refurbished civic center. After two years in Springfield, the Whalers returned to Hartford on February 6, 1980. A capacity crowd watched them defeat the Kings by a score of 7-3. Many in attendance were charter members of the I-90 Club, a group of diehard fans who made the trek to Springfield to cheer on their beloved Whalers. Where there's a Whale, there's a way. (Courtesy of the Sports Museum.)

THE NHL

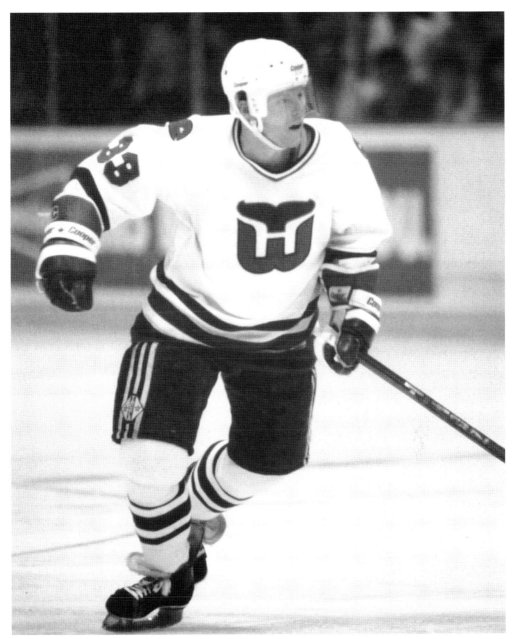

MARK FUSCO. The Whalers signed the 1983 Hobie Baker Award winner Mark Fusco as a free agent in February 1984. The Harvard all-star played well for the Whalers, but a head injury forced his early retirement after only two seasons. (Photograph by Steve Babineau.)

HARTFORD WHALERS

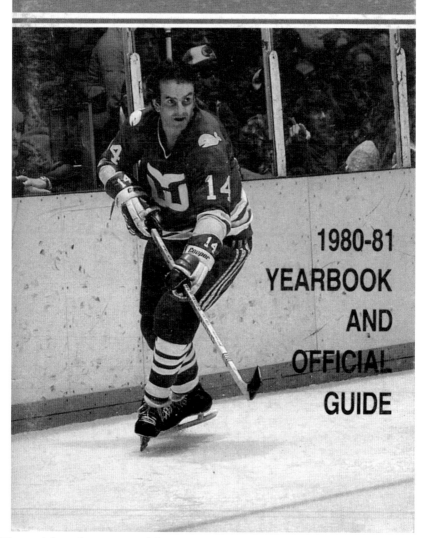

1980-81
YEARBOOK
AND
OFFICIAL
GUIDE

DAVE KEON. After 15 seasons and four Stanley Cups, and having won the Calder Memorial Trophy (NHL Rookie of the Year), the Conn Smythe Trophy (playoff MVP), and Lady Byng Memorial Trophy (for most gentlemanly play), the eight-time NHL All-Star Maple Leafs captain Dave Keon left Toronto to join the Minnesota Fighting Saints. After the Saints folded for the second time, he found himself with New England, where he finished his career in 1982. He was inducted into the Hockey Hall of Fame in 1986. (Courtesy of the Sports Museum.)

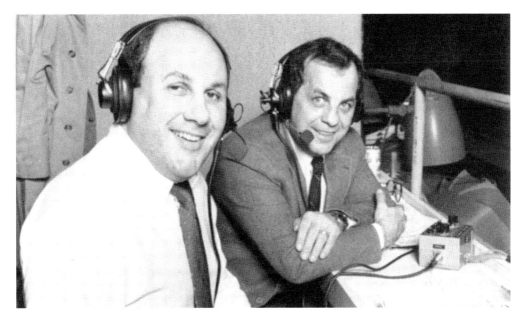

CHUCK KAITON. "The Voice of the Whalers," Chuck Kaiton (left) sits in the booth with color man Andre Lacroix. A Whaler as well as a Connecticut institution, Kaiton won the prestigious Foster Hewitt Award for Excellence in Sports Broadcasting in 2004. (Courtesy of the Sports Museum.)

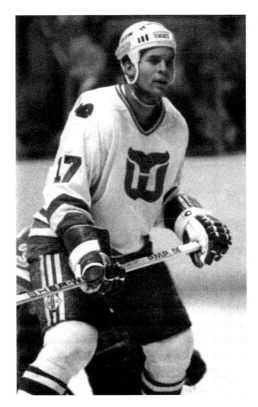

RAY NEUFELD. The big right-winger was chosen by the Whalers in the 1979 draft. The first black player in the team's history, he was involved with the 1985 trade that brought Dave Babych to Hartford. (Courtesy of the Sports Museum.)

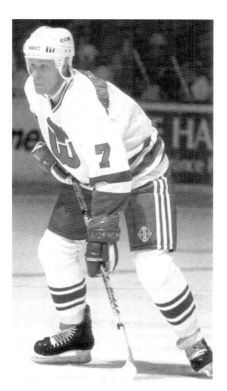

RANDY CUNNEYWORTH. Originally drafted by the Sabres, Randy Cunneyworth saw limited play and was traded to the Pittsburgh Penguins in 1985. After a stint with Winnipeg in 1989–1990, he was traded to the Whalers for Paul MacDermid. He spent five seasons in green and blue before being traded to Chicago. He spent four seasons in Ottawa before ending his NHL career where it began, in Buffalo. (Courtesy of Carleton McDiarmid.)

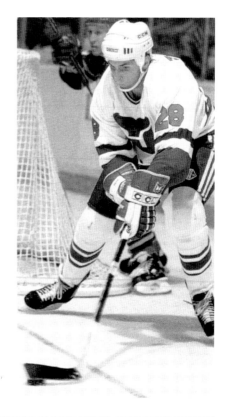

MIKE TOMLAK. Thunder Bay, Ontario, native Mike Tomlak played 141 games over parts of four seasons with the Whalers. A checking center with a long reach, the six-foot-three-inch Tomlak was a solid two-way player. (Courtesy of Carleton McDiarmid.)

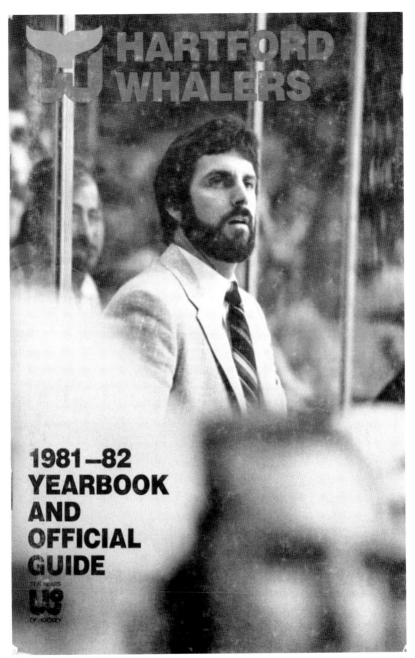

COACH LARRY PLEAU. As a player, coach, and general manager, Larry Pleau was a part of the Whalers organization for 17 years. The first player signed by the New England Whalers, he played seven seasons in green, retiring before the team joined the NHL. He became an assistant coach with the club in 1980–1981, taking over as head coach from Don Blackburn that same year. He coached until 1983, then coached the club's minor-league affiliate in Binghamton until 1988 when he returned to the Hartford bench. He was replaced in 1989 by another original Whaler, Rick Ley. (Courtesy of the Sports Museum.)

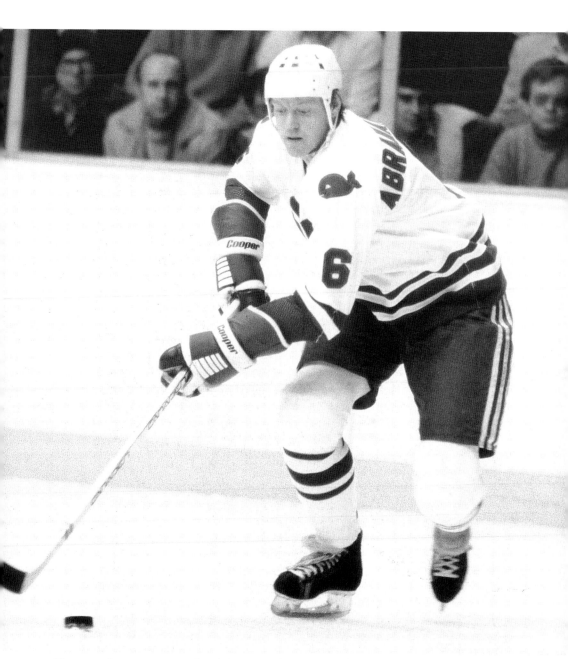

Thommy Abrahamsson. Swedish twins Christer and Thommy Abrahamsson were part of the wave of European players who came to play in the WHA. While still a rarity in the NHL, the WHA actively sought out talented players such as Ulf Nilsson and Anders Hedberg, who starred for Winnipeg. Thommy signed to play for the Whalers in 1974–1975 and played with them until 1977, when he returned to play in Sweden. He returned to Hartford in 1980–1981 but played only 32 games. Goaltender Christer also played from 1974 until 1977, posting a 3.58 goals against average (GAA) in 102 games. (Photograph by Steve Babineau.)

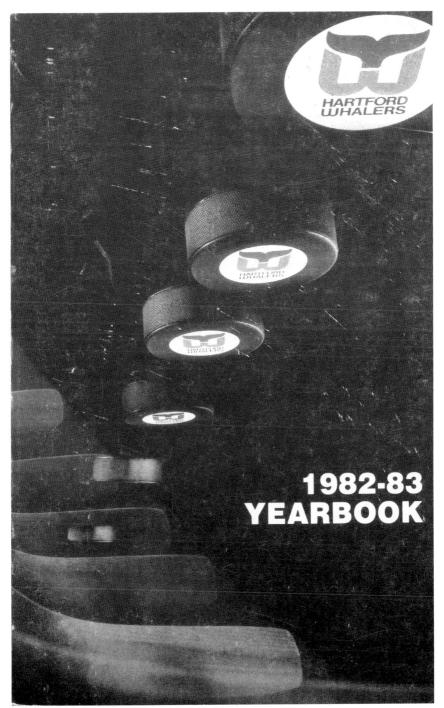

THE **1982–1983 YEARBOOK.** In 1982–1983, the Whalers finished dead last in the Adams Division. Despite 90- and 86-point seasons by Ron Francis and Blaine Stoughton respectively, the team was going nowhere. In May 1983, the Whalers brought in hockey legend Emile "Cat" Francis to try and turn things around. (Courtesy of Matt Brady.)

WHO CAN FORGET THE COOPERALLS? Blaine Stoughton sports one of those experiments that failed, the Cooperall long pants. During the 1981–1982 season, the Flyers adopted the new style as a test, followed by the Whalers in 1982–1983. The long pants were supposed to be the next generation in hockey gear. They were not. Not only did they look like sweatpants, they acted like them too, being hot, uncomfortable, and slippery when a player went down on the ice. They were soon relegated to the oddities section of hockey history. (Courtesy of the Sports Museum.)

THE NHL

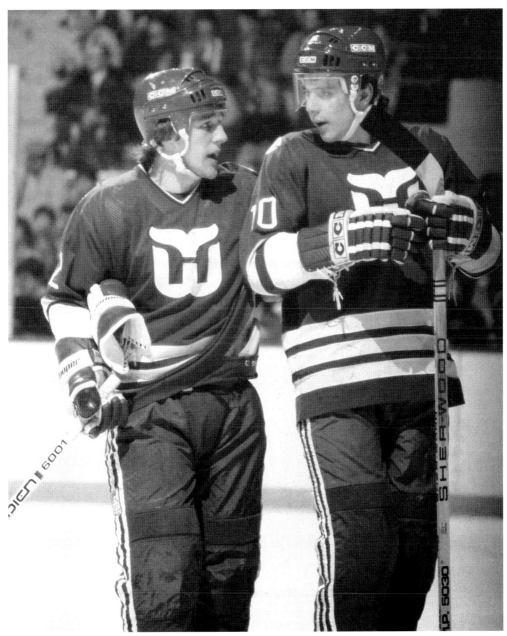

ROAD GREENS. Doug Sulliman (left) and Ron Francis are seen here sporting the new look. The cooperalls only looked slightly better with the road greens, which is not saying much. (Photograph by Steve Babineau.)

SYLVAIN TURGEON. The man they called "Sly" was taken second overall by Hartford in the 1983 entry draft. Although No. 1 pick Brian Lawton was a disappointment, other members of that class chosen after Sylvain Turgeon included Pat LaFontaine, Steve Yzerman, Tom Barrasso, John MacLean, Russ Courtnall, and Cam Neely. A left-winger with a quick, accurate shot, Turgeon quickly made a name for himself as on the power play. He was a key member of the Adams Division–winning team in 1987, playing on a line with Kevin Dineen and Ron Francis. Hampered with nagging injuries, he played for the Whalers until being traded to New Jersey for another soon-to-be fan favorite, Pat Verbeek. (Courtesy of the Sports Museum.)

PAT VERBEEK. Crippled by bad trades and weak management, the early 1990s were dark days for Hartford. Whaler fans consider the acquisition of Pat Verbeek as one of the few good deals made during this period. Coming to Hartford in a swap for Sylvain Turgeon, the gritty winger soon became a fan favorite. In 1989–1990, he played on the top line along with Ron Francis and Kevin Dineen (the three combined scored 101 goals) and over six seasons had two 40-plus goal years. He led the club in scoring in 1993–1994 and wore the captain's C from 1992 until he was traded to the Rangers in 1995. A testimony to his toughness is the farming accident that nearly cost him the use of his hand as well as his career. On May 15, 1985, Verbeek's left thumb was cut off and his fingers badly damaged by a fertilizer bin auger on his farm. The thumb was retrieved from the bin and in a delicate microsurgical operation was reattached. After extensive physical therapy he regained use of the hand and was able to attend training camp that fall. (Courtesy of the Sports Museum.)

1983-84 YEARBOOK

THE 1983–1984 YEARBOOK. Even though they were still last in the Adams Division, the Whalers finished the season as the most improved team in the NHL. Things were looking up. (Courtesy of the Sports Museum.)

THE NHL

TORRIE ROBERTSON. The Whalers' all-time penalty leader with 1,368 minutes in 299 games, Torrie Robertson delighted Hartford fans by abusing opposing players at every opportunity. Originally a Capitals prospect, he became an NHL regular in Hartford as well as a fan favorite. He dropped his gloves for the last time in the NHL with Detroit in 1989–1990. (Courtesy of the Sports Museum.)

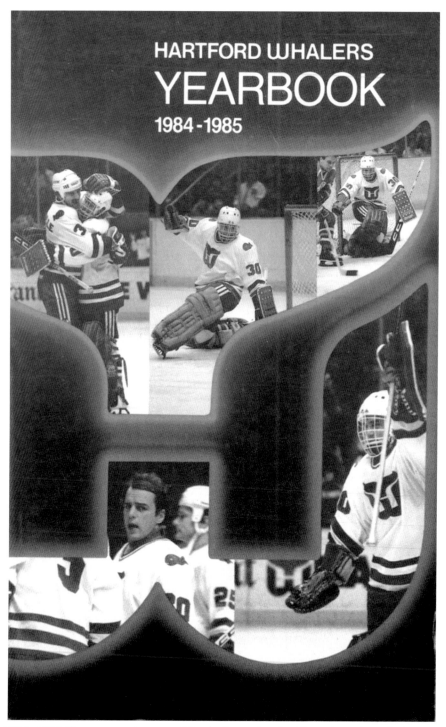

THE 1984–1985 YEARBOOK. As part of Emile Francis's rebuilding plan, the Whalers acquired goalies Steve Weeks, Peter Sidorkiewicz, and Mike Liut and center Dean Evason during the 1984–1985 season. (Courtesy of the Sports Museum.)

JOEL QUENNEVILLE. A Windsor, Ontario, native, Joel Quenneville was Toronto's first choice in the 1978 entry draft. He spent parts of two seasons with the Leafs before being part of what is arguably one of the worst trades in Maple Leafs history. In one of their purges, Leafs owner Harold Ballard and general manager Punch Imlach sent Quenneville and Lanny McDonald to the Colorado Rockies in exchange for Wilf Paiement and Pat Hickey. The immensely popular McDonald went from Colorado to Calgary, where he captained the Flames to the 1989 Stanley Cup. Quenneville stayed with Colorado until the franchise relocated to New Jersey and joined the Whalers in 1983 following off-season trades first to Calgary and then to Hartford. He played in Hartford for seven years and was twice named the team's most valuable defenseman. (Courtesy of the Sports Museum.)

AL SIMS. Beginning his professional career with the talent-rich Bruins in 1973, defenseman Al Sims spent his time bouncing between Boston and Rochester. Picked by the Whalers via the expansion draft, Sims played two respectable seasons in Hartford before moving on to the Kings organization. (Photograph by Steve Babineau.)

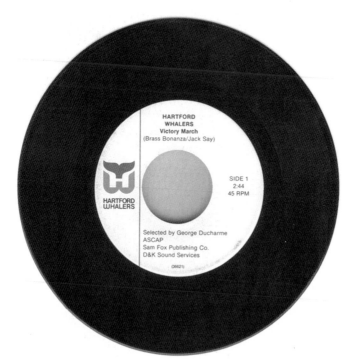

"Brass Bonanza." Like "Sweet Georgia Brown" and the Harlem Globetrotters, few teams have a song so associated with them as "Brass Bonanza" is with the Whalers. In the mid-1970s, it was felt that something was needed to rouse the crowd when the team scored. "Brass Bonanza" fit the bill and soon became an arena standard. It was even available as a record and tens of thousands were produced. (Courtesy of Brassbonanza.com.)

Risto Siltanen. While the WHA lead the way in signing European players, the Whalers did not have a Finnish player until they acquired Risto Siltanen from Edmonton in 1982. A power-play specialist, he finished his NHL career with the Nordiques, another former WHA club, in 1987. (Courtesy of the Sports Museum.)

THE GOALIES OF 1984–1985. John Garrett (right) and Mike Veisor (below) were the goalies for the 1984–1985 team. Note the understated Pucky the Whale stickers on Veisor's mask. (Courtesy of the Sports Museum.)

THE HARTFORD WHALERS

ULF SAMUELSSON. Ulf Samuelsson was drafted out of Sweden as the Whalers' 4th choice (67th overall) in the 1982 entry draft. The hard-hitting defenseman came up to the big club in the 1984–1985 season and played 463 games for the Whalers before being traded along with Ron Francis and Grant Jennings to Pittsburgh in 1991 for John Cullen, Jeff Parker, and Zarley Zalapski. The unpopular trade was widely decried by Hartford fans. The Penguins went on to win the Stanley Cup in 1991 and 1992. (Photograph by Steve Babineau.)

THE NHL

NICK FOTIU. Legend has it that Nick Fotiu started the practice of tossing pucks to the fans after pregame warm-ups. He definitely tossed his weight around in games. Fotiu was the kind of player who threw devastating checks, fought against the game's toughest, and played every game with energy and enthusiasm. He played for the Whalers in both leagues, logging 110 games with the New England Whalers between 1974 and 1976 and 106 games with the Hartford Whalers from 1979 to 1981. (Photograph by Steve Babineau.)

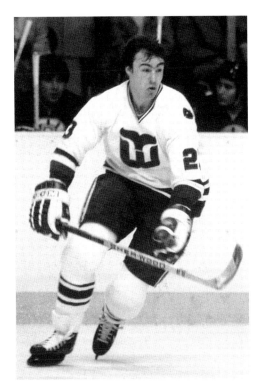

TRAINERS JOE ALTOTT AND SKIP CUNNINGHAM. Skip Cunningham was with the team as a trainer and equipment manager through its entire existence and is still with the Carolina Hurricanes. (Courtesy of the Sports Museum.)

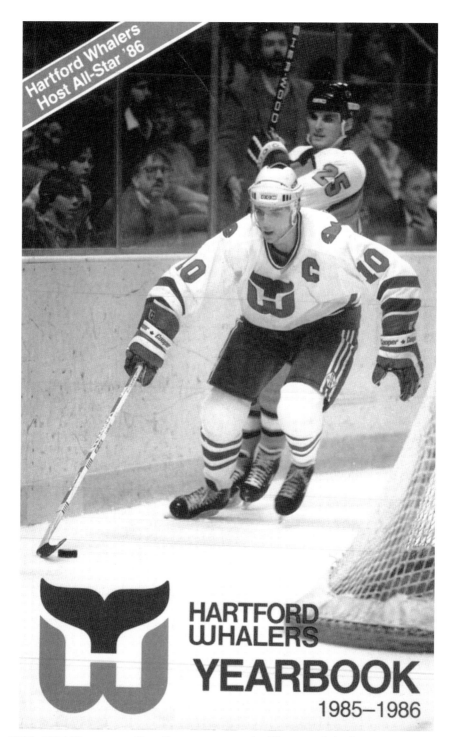

THE 1985–1986 YEARBOOK. Ron Francis outruns the Flyers, and the banner announces that Hartford will host the 1986 all-star game. The Wales Conference would defeat the Campbell Conference 4-3 before a sellout crowd at the Hartford Civic Center. (Courtesy of Matt Brady.)

BLAINE STOUGHTON. Blaine Stoughton and Bobby Hull were the only players to score 50 goals in both the WHA and the NHL. A fearsome scorer with the Flin Flon Bombers, Stoughton was drafted by the Penguins and later traded to the Maple Leafs. Never living up to expectations in the NHL, he jumped to the WHA in 1976–1977. With the exception of a 52-goal, 52-assist season with Cincinnati, he did not develop his prolific scoring touch until the Whalers' first NHL season, when he scored 100 points and led the league in goals with 56. He continued his scoring feats until he was traded to the Rangers in 1984, where he finished his NHL career. (Photograph by Steve Babineau.)

SYLVAIN COTE. After a successful junior career in Quebec, Sylvain Cote was selected by the Whalers in the 1984 entry draft. After a season in the NHL, he returned to play in the Quebec Major Junior Hockey League (QMJHL) but came back to Hartford in 1985–1986. Cote played five years and 382 games for the Whalers before being traded to Washington in 1991. He patrolled the blue line for the Capitals before going to the Maple Leafs in 1998. In 1999, he was traded to the Blackhawks and midway through the season was traded with Dave Manson to the Dallas Stars. During that season, Cote appeared in his 1,000th career game and went to the Stanley Cup finals. He returned to Washington as a free agent, where he finished his career. (Courtesy of Carleton McDiarmid.)

BOBBY HOLIK. A native of the Czech Republic and one-time teammate of Jarimir Jagr, Bobby Holik scored 21 goals in each of his two seasons in Hartford. He was traded to New Jersey in the Sean Burke deal and won a Stanley Cup there in 1995. (Courtesy of Carleton McDiarmid.)

THE NHL

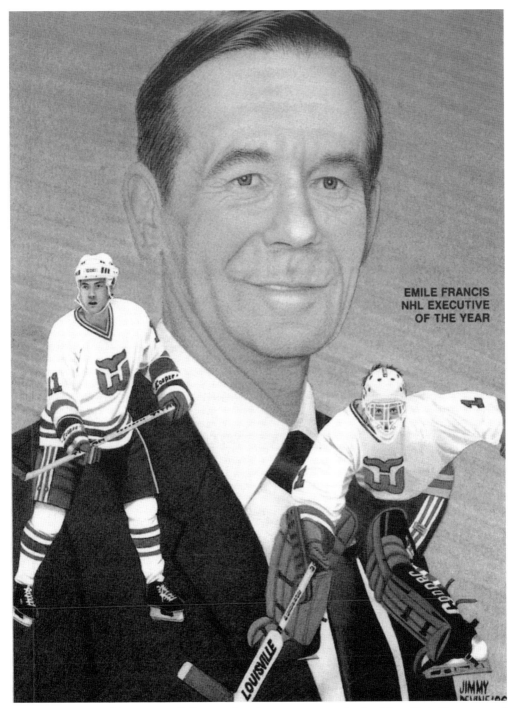

EMILE FRANCIS
NHL EXECUTIVE
OF THE YEAR

JIMMY
DEVINE/86

THE 1986–1987 YEARBOOK. Following his long success with the New York Rangers and St. Louis Blues, Emile Francis was brought in to be the architect of a new Whalers team. (Courtesy of the Sports Museum.)

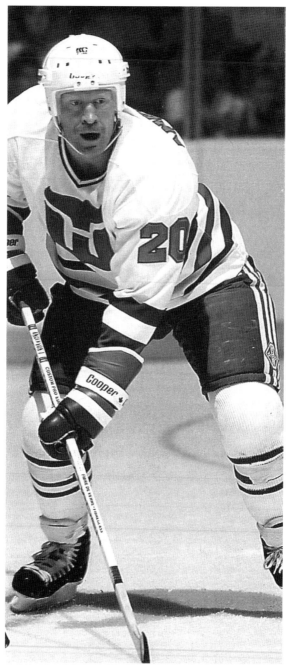

JOHN ANDERSON. Originally drafted by the Maple Leafs in 1977, John Anderson was a Toronto native who played his junior hockey with the Marlies. He played nearly eight seasons with the Leafs before being traded to Quebec before the 1985 season. In the spring of 1986, he was on the move again, this time traded to the Whalers for Risto Siltanen. Teamed up with Ron Francis and Kevin Dineen on the first line, his scoring touch was a factor in getting the Whalers to the playoffs. (Courtesy of the Sports Museum.)

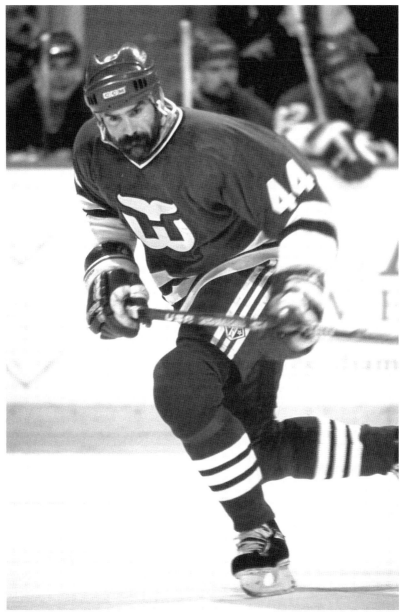

DAVE BABYCH. Defenseman Dave Babych was one of those rare players who made the leap from juniors to the NHL without ever playing in the minors. He blossomed into an all-star with the Winnipeg Jets, where he played for nearly six seasons. It was during this last season that he was traded to the Whalers for Ray Neufeld, considered one of the best trades in team history. Although not as productive as he had been in Winnipeg, Babych quickly became a fan favorite. A solid, hardworking, and consistent player as well as a superb skater, he prowled the Whalers' blue line for six years. In 1991, he was claimed by Minnesota in the expansion draft but was dealt to Vancouver, where he continued to have a productive career. (Photograph by Steve Babineau).

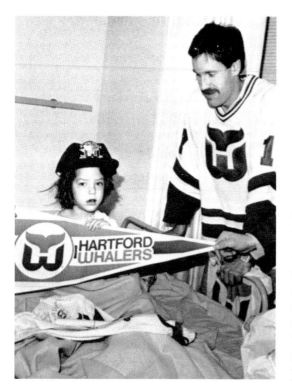

DOING GOOD IN THE COMMUNITY. The Whalers organization was involved with several community outreach and charity organizations. At left, Brent Peterson gives a Whalers pennant to a young fan at the University of Connecticut Health Center's Children's Cancer Wing. Below, Tiger Williams (left), his wife, Brenda, and Sylvain Turgeon visit patients at St. Francis Hospital. (Courtesy of John Bishop.)

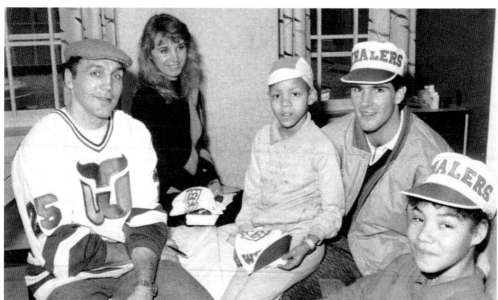

THE NHL

JACK EVANS. Jack "Tex" Evans played several years in the WHL, AHL, and NHL, including stints with the Rangers and Blackhawks, and was a member of Chicago's 1961 Stanley Cup team. As coach of the Whalers, he set several records, including most games (374), most wins (163), most losses (171), most ties (37) and most Stanley Cup games (16). The high point of his time behind the bench was the Whalers' winning of the Adams Division championship in 1986–1987. In February 1988, he was replaced by Larry Pleau. (Courtesy of Matt Brady.)

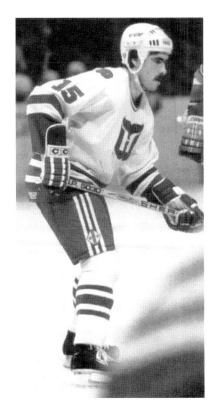

DAVE TIPPETT. The captain of the 1984 Canadian Olympic team, Dave Tippett was signed as a free agent by the Whalers that year. Making his Hartford debut in March, he embarked on a Doug Jarvis–like streak of 419 consecutive games before an injury sidelined him in October 1989. He was traded to Washington in 1990 and after another stint with the Canadian National Team in 1992 played for Pittsburgh and Philadelphia. (Courtesy of Carleton McDiarmid.)

HARTFORD
WHALERS
® **1988-89 YEARBOOK**

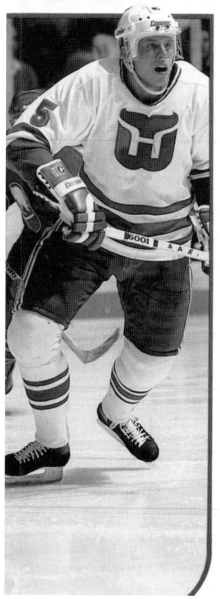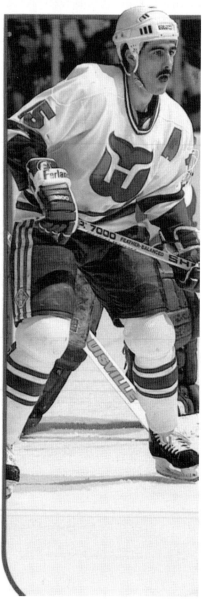

THE 1988–1989 YEARBOOK. Ulf Samuelsson (left) and Dave Tippett grace the cover of the 1988–1989 yearbook. (Courtesy of the Sports Museum.)

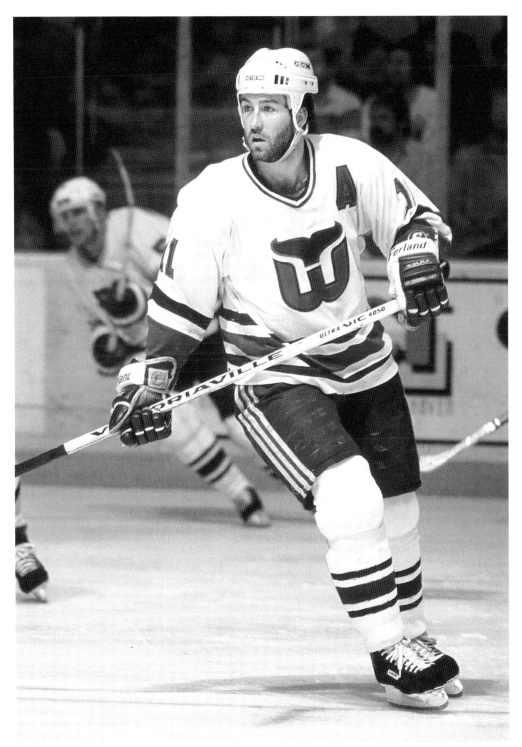

KEVIN DINEEN AND ULF SAMUELSSON. Sporting a playoff beard, alternate captain Kevin Dineen and Ulf Samuelsson (rear) begin a rush up ice. (Photograph by Steve Babineau.)

THE HARTFORD WHALERS

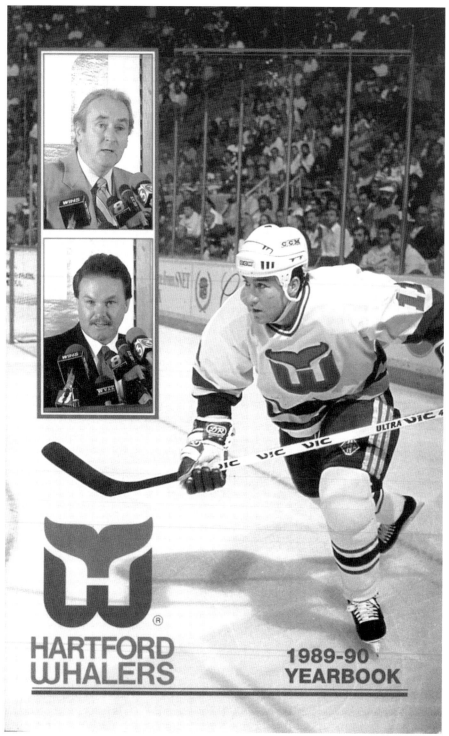

THE 1989–1990 YEARBOOK. General manager Eddie Johnston (inset, top) and coach Rick Ley join Kevin Dineen on the cover of the 1989–1990 yearbook. (Courtesy of the Sports Museum.)

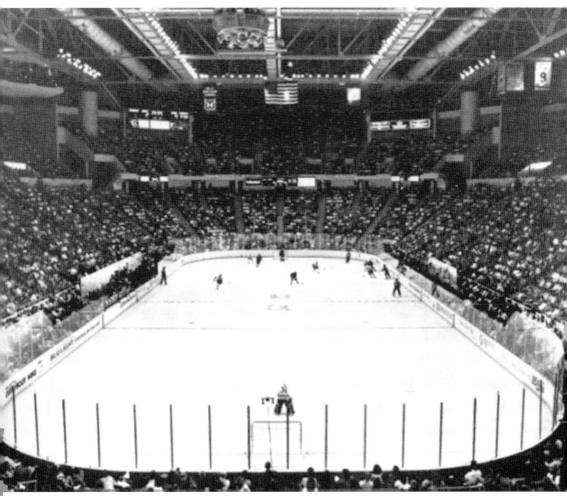

THE SHOWCASE OF NEW ENGLAND. The 1989–1990 Whalers yearbook describes the Hartford Civic Center in these glowing terms: "The Hartford Civic Center Coliseum is the largest arena between New York and Montreal, and between Boston and Buffalo. It is part of a $70 million complex on seven and one-half acres of prime downtown real estate, and it is linked to a mall of 70 shops (Civic Center Mall), the 22-story Sheraton-Hartford Hotel, the 38-story CityPlace and the eight-story Aetna Realty Building that includes the Whalers new offices (8th floor). The Civic Center Coliseum seats 15,552 for ice hockey games and 16,162 for concerts, the largest capacity building in New England. It draws spectators from a metropolitan area that extends to a 70-mile radius of the State Capital and boasts a population of 2.3 million people. The Civic Center Coliseum offers a wide variety of entertainment year-round, headlined by the Hartford Whalers of the National Hockey League. The University of Connecticut and University of Hartford men's basketball teams are the two other top attractions, along with major names in entertainment and world famous circus and ice show performers." (Courtesy of the Sports Museum.)

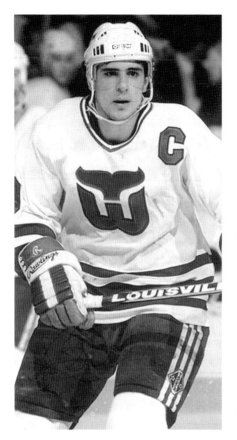

RON FRANCIS. A quiet hero, most fans would be surprised to learn that Ron Francis's 1,731 games played put him third behind Gordie Howe (1,767) and Mark Messier (1,756). Among his other statistics, he is among the all-time leaders in assists (1,249, second only to Wayne Gretzky) and points (1,798, fourth behind Gretzky, Messier, and Howe). In his 23 seasons, he scored 20 or more goals in 20 of them. One of the darkest days in Whaler history was when Francis was traded to Pittsburgh along with Ulf Samuelsson. Although he won two Stanley Cups with the Penguins, his name will always be synonymous with Hartford. (Courtesy of the Sports Museum.)

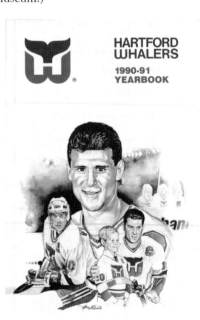

KEVIN DINEEN. The son of coach Bill Dineen, Kevin Dineen grew up in Glastonbury, Connecticut. Drafted by the Whalers in 1982 while playing for the University of Denver, he joined the team in the 1984–1985 season. A tough, hardworking player of whom it was said "the bigger the game the bigger he played," Dineen was a key member of the Whalers teams of the 1980s and 1990s. Traded to Philadelphia in 1991 (where he later became captain), Dineen returned to Hartford in 1995. He was the last captain of the club, wearing the C in 1996–1997. Fittingly, he scored the last goal in the team's last game. He is one of two Whalers (along with Ron Francis) to play more than 500 games with the club. (Right, courtesy of the Sports Museum; below, photograph by Al Ruelle.)

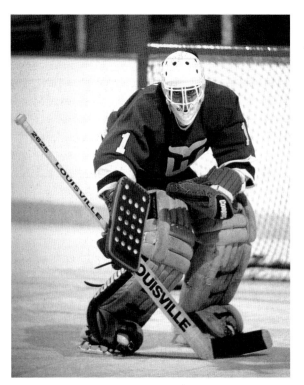

MIKE LIUT. The acquisition of Mike Liut from the Blues in a trade for Greg Millen and Mark Johnson was one of the key moves in turning the Whalers team into a contender. Sharing the net-minding duties with Steve Weeks, Mike Liut was the backbone of the "Whalermania" era. (Photograph by Steve Babineau.)

DOUG JARVIS. On December 26, 1986, Doug Jarvis surpassed Gary Unger's 914 consecutive game record to become the NHL's new iron man. Jarvis went on to set a new record of 964 straight games. Not surprisingly, he won the Bill Masterton Memorial Trophy that season, awarded to the player who "best exemplifies the qualities of perseverance, sportsmanship and dedication to hockey." (Photograph by Steve Babineau.)

THE NHL

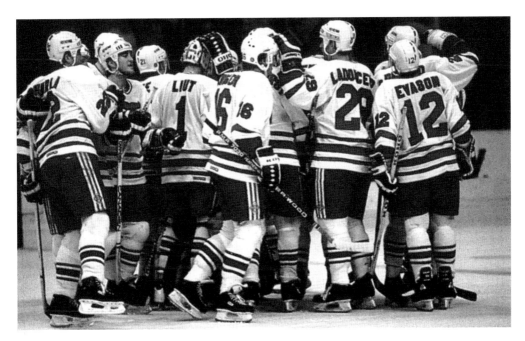

AND THEY CALLED IT WHALERMANIA. The 1986–1987 season had an auspicious beginning, with the Whalers opening the season at home for the first time since joining the NHL. They also possessed an unprecedented level of talent. Emile Francis was constantly fine-tuning the team that had gone to the playoffs the previous season. Behind coach Jack Evans were captain Ron Francis, Ray Ferraro, Doug Jarvis, Paul Lawless, Sylvain Turgeon, Kevin Dineen, Paul MacDermid, Ulf Samuelsson, Joel Quenneville, and Dave Babych with Mike Liut and Steve Weeks in net. By mid-season the Whalers were on their way to their best season since joining the NHL. Finishing first place in the Adams Division, they went on to play the Nordiques, who took the division crown the previous year. After winning the first two games in Hartford, the series shifted to Quebec. Losing three straight, the Whalers fought the Nordiques to a tie in Game 6, forcing an overtime. Quebec's Peter Stasny scored to give the Nordiques a 5-4 win and put an end to the Whalers Stanley Cup dreams. Although they lost the series, the Whalers gave the Hartford fans "a whale of a season." (Courtesy of the Sports Museum.)

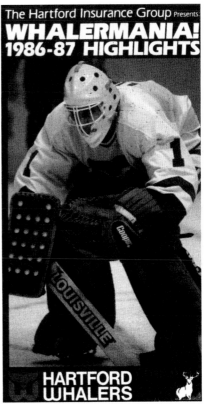

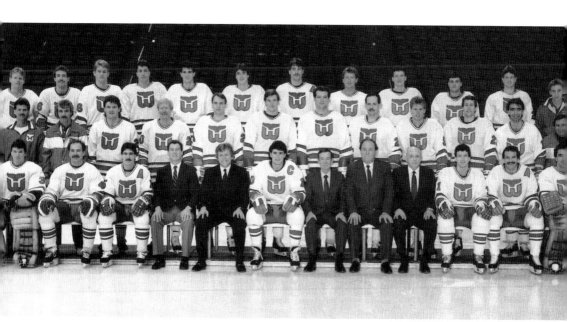

THE 1986–1987 ADAMS DIVISION CHAMPIONS. Pictured are, from left to right, (first row) Steve Weeks, Dave Babych, Dave Tippett, assistant coach Claude Larose, chairman and managing partner Howard Baldwin, captain Ron Francis, president and general manager Emile Francis, head coach Jack Evans, assistant general manager Bob Crocker, Kevin Dineen, Joel Quenneville, and Mike Liut; (second row) assistant equipment manager Steve Latin, assistant trainer and head equipment manager Skip Cunningham, Paul Lawless, John Anderson, Mike McEwen, Dana Murzyn, Dave Semenko, Randy Ladouceur, Ulf Samuelsson, Paul MacDermid, Wayne Babych, and head trainer Tom Woodcock; (third row) Doug Jarvis, Ray Ferraro, Gord Sheveren, Shane Churla, Sylvain Turgeon, Stewart Gavin, Scot Kleinendorst, Torrie Robertson, Sylvain Cote, Dean Evason, Pat Hughes, and clubhouse assistant Howard Baldwin Jr. (Courtesy of the Sports Museum.)

THE NHL

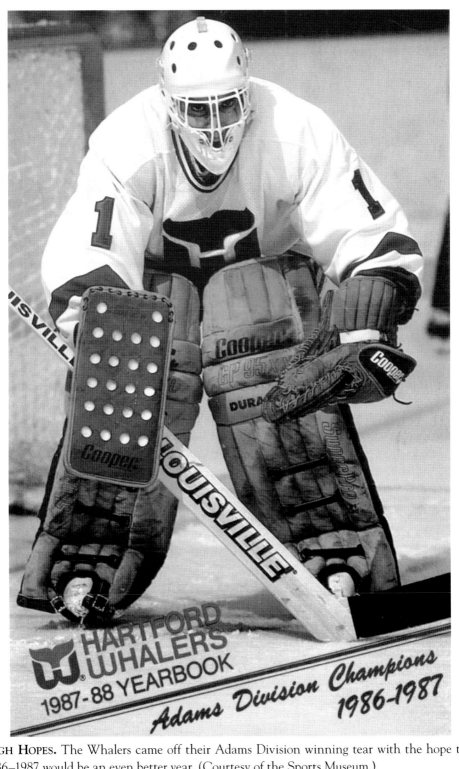

HIGH HOPES. The Whalers came off their Adams Division winning tear with the hope that 1986–1987 would be an even better year. (Courtesy of the Sports Museum.)

THE ROAD TO HARTFORD BEGINS IN SPRINGFIELD. Yvon Corriveau, like many future Whalers, played his minor league hockey in Springfield. The Springfield connection with the Whalers runs deep. The Big E was the first home for the team while it waited for the Hartford Civic Center to be completed, and the Springfield Civic Center was its temporary home following the collapse of that arena's roof. (Courtesy of Skip Cunningham.)

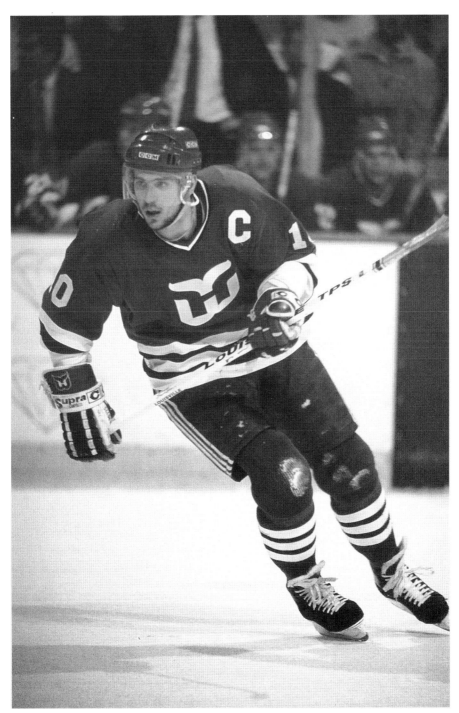

THE CAPTAIN, RON FRANCIS. No one is more closely associated with the Hartford Whalers than Ron Francis. Hartford's first choice in the 1981 entry draft, Francis played 10 seasons in Hartford. He was traded to Pittsburgh, where he played seven seasons before returning to the team, now in North Carolina. (Photograph by Steve Babineau.)

THE HARTFORD WHALERS

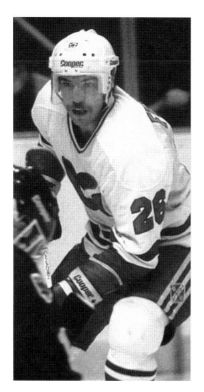

RAY FERRARO. Another Whalers mainstay of the 1980s, Ray Ferraro played over 400 games in his six years in Hartford. In one of many questionable trades of the era, in 1990 he was dealt to the New York Islanders for Doug Crossman. He went on to have a long and successful career with the Islanders, Rangers, and Kings. (Left, courtesy of the Sports Museum; below, courtesy of Carleton McDiarmid.)

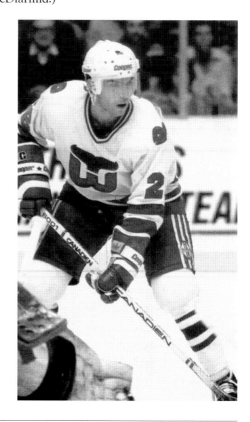

ULF SAMUELSSON TAKES DOWN BOBBY CARPENTER. The Whalers and the Bruins developed a heated rivalry over the years. (Courtesy of the Sports Museum.)

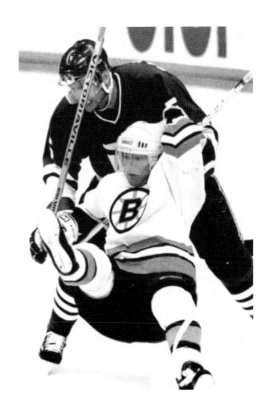

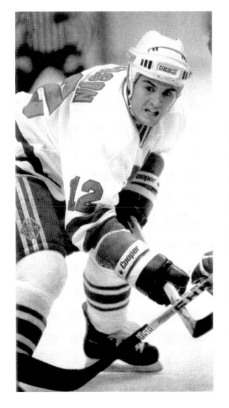

DEAN EVASON. Originally the property of the Washington Capitals, Dean Evason was traded to the Whalers late in the 1984–1985 season, where he split the his time between Hartford and Binghamton of the AHL. He did the same in 1985–1986 season before coming up to stay in 1886–1987, playing the next five full NHL seasons with the Whalers. A valuable member of the Adams Division–winning team, Evason centered the line between Paul Lawless and Stewart Gavin, called the "LEG" line (Lawless, Evason, and Gavin). He was traded to San Jose prior to the 1991–1992 season and played there two years before being traded to the Dallas. After two years in Dallas, he was signed as a free agent by Calgary, where he played his final NHL season in 1996–1997. (Courtesy of Carleton McDiarmid.)

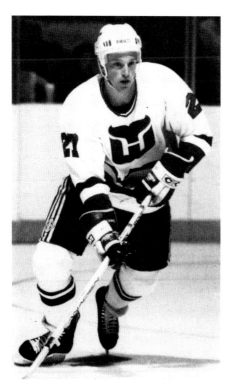

SCOTT YOUNG. A solid two-way player with a hard shot, Scott Young, like many Whalers before him, played college hockey in Boston. Although he was on playoff teams in Hartford, he won a Stanley Cup in Pittsburgh. He later played for the Quebec Nordiques and went with them to Colorado when they became the Avalanche. He added another Stanley Cup to his trophy case while there before moving even farther west to finish his career in Anaheim. (Courtesy of John Bishop.)

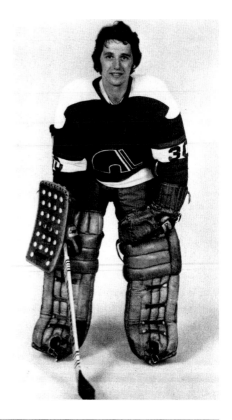

RICHARD BRODEUR. "King Richard" Brodeur enjoyed a long career with the Quebec Nordiques, New York Islanders, and Vancouver Canucks before joining the Whalers late in the 1987–1988 season. The goalie of Quebec's 1977 Avco Cup–winning team, Brodeur is one of the few players to have played in every WHA season. He was also a key to Vancouver's playoff success, helping them get to the Stanley Cup finals in 1982. He saw limited duty with the Whalers, playing in only eight games before retiring. (Courtesy of the Boston Herald.)

THE NHL

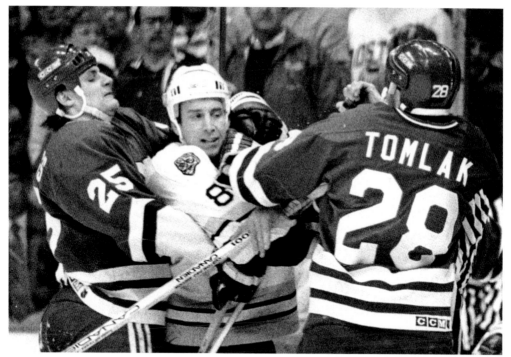

IT TAKES TWO. Grant Jennings and Mike Tomlak double-team Cam Neely during the first period of Game 7 of the 1990 playoffs. (Courtesy of the Boston Herald.)

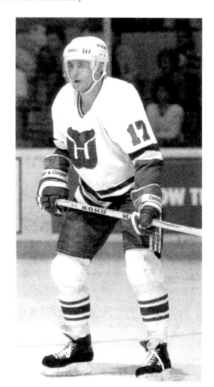

TODD KRYGIER. Taken in the supplemental draft out of the University of Connecticut, Todd Krygier scored 18 goals in his rookie year. After two seasons in Hartford, he was traded to Washington. (Courtesy of Carleton McDiarmid.)

THE HARTFORD WHALERS

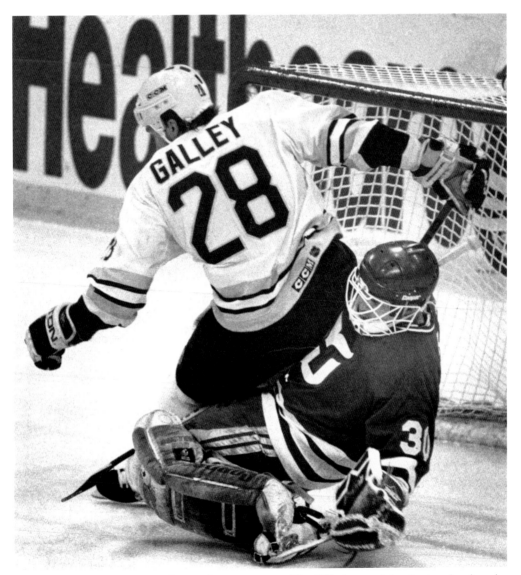

GARY GALLEY DROPS IN ON PETER SIDORKIEWICZ. The Whalers and the Bruins developed a strong rivalry including several tough divisional series. The 1990 playoffs were especially hard fought. The Whalers took the Bruins to seven games before being knocked out; the Bruins went on to the Stanley Cup finals. Many point to Game 4 as the game that took the wind out of the Whalers' sails. The Whalers were leading the Bruins 5-2 going into the third period. A win would put them up 3-1 in the series, but the Bruins roared back in the third, scoring four goals, including the game winner, with a mere 1 minute, 44 seconds remaining to play. (Courtesy of the Boston Herald.)

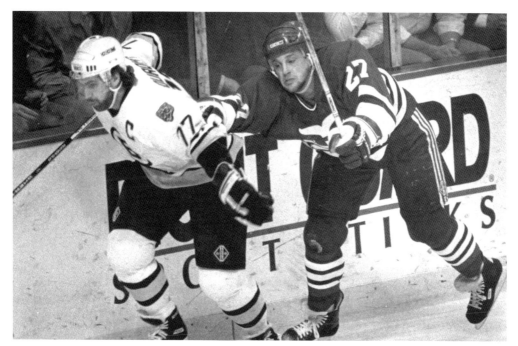

SCOTT YOUNG AND RAY BOURQUE. Scott Young chases Bruins captain Ray Bourque in Game 7 of the 1990 playoffs. (Courtesy of the Boston Herald.)

MAULED BY BRUINS. Scott Young finds himself trapped between Boston's John Carter and John Byce. No stranger to Boston, Young played at Boston University and was later selected to play on the 1988 Olympic team (alongside such future stars as Brian Leetch and Craig Janney) before joining the Whalers. He played for the Whalers until he was traded to the Penguins in 1992. While a championship eluded him in Connecticut, he played on Stanley Cup teams in Pittsburgh and Colorado. (Courtesy of the Boston Herald.)

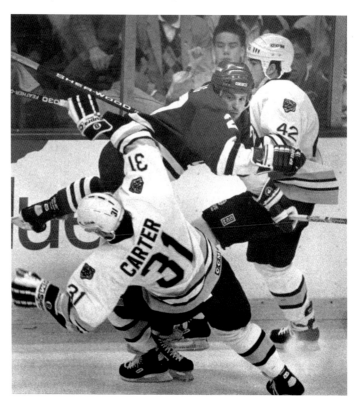

THE HARTFORD WHALERS

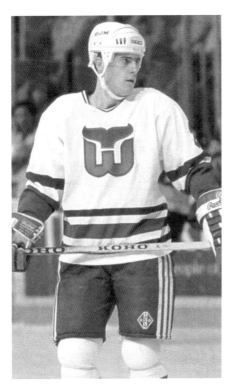

BRAD SHAW. A veteran of the Whalers' minor-league system, having played for the Salt Lake Golden Eagles and the Binghamton Whalers, Brad Shaw made occasional appearances with the big club until 1989–1990, when he came up to stay. Shaw played for the Whalers until 1992 when he went to the Senators. After two solid seasons in Ottawa, he mostly played in the minors except for brief stints with Washington and St. Louis. He was a player–assistant coach with the Detroit Vipers of the IHL and turned to coaching full-time after retiring from hockey. (Courtesy of Carleton McDiarmid.)

JIMMY ROBERTS. The veteran defenseman enjoyed a long career with Montreal and St. Louis (including five Stanley Cups with the Habs) before retiring in 1978. After successfully coaching in the Whalers' minor-league system, Jimmy Roberts was brought up to the big club. He coached one season in Hartford, but it was a memorable one, 1991–1992. When Brian Burke took over from Eddie Johnston, he decided to replace Roberts with Paul Homgren. (Courtesy of the Sports Museum.)

THE NHL

EDDIE JOHNSTON. Eddie Johnston (right) was named general manager in 1989 and embarked on the most controversial reign in team history. Although the team went to the playoffs in 1990, Johnston made several questionable trades. Among them was the deal that sent Ron Francis, Ulf Samuelsson, and Grant Jennings to Pittsburgh for John Cullen, Zarley Zalapski, and Jeff Parker. The Penguins went on to win the Stanley Cup; the Whalers went into a long malaise. He was fired in May 1992 and was eventually hired by Pittsburgh. (Courtesy of the Sports Museum.)

KAY WHITMORE. After a promising junior career with the Peterborough Petes, Kay Whitmore split his time between the majors and the minors. He did well in the minors, winning a Calder Cup championship with Springfield and earning MVP honors, but NHL success continued to elude him. He was traded to Vancouver in 1992 where he played for three seasons. (Courtesy of Carleton McDiarmid.)

PETER SIDORKIEWICZ. Polish-born Peter Sidorkiewicz was originally drafted by Washington, but only played in its minor-league system before being traded to Hartford. After a one-game appearance in 1987–1988, he came up to stay the following year. In the expansion draft, he was taken by Ottawa, a team that won just 10 games in its inaugural season. (Courtesy of Carleton McDiarmid.)

THE NHL

MURRAY CRAVEN. A journeyman who played over 1,000 NHL games, Murray Craven played parts of two seasons in Hartford. Coming from Philadelphia in the Kevin Dineen trade in 1991, he was a solid, versatile veteran who had played on two Flyers teams that had reached the Stanley Cup finals (1985 and 1987). (Courtesy of Carleton McDiarmid.)

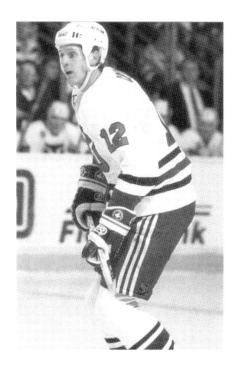

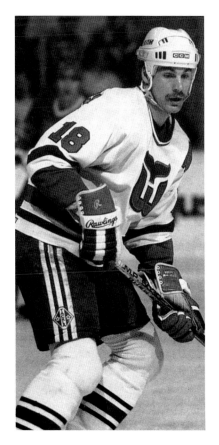

SCOT KLEINENDORST. A big, rugged defenseman from Minnesota, Scot Kleinendorst was drafted by the Rangers while still at Providence College. After playing for the United States in the 1982 world championships, he joined the Ranger organization, splitting his time between Broadway and Tulsa. Traded to Hartford for Blaine Stoughton in 1984, he played parts of five seasons with the Whalers. A solid player despite being hampered by injuries, he was a member of the team that swept Quebec in the first round of the 1986 playoffs. Despite all this, his name was still spelled wrong in the 1987–1988 media guide. (Courtesy of the Sports Museum.)

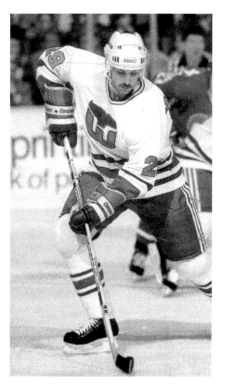

FRANK PIETRANGELO. Originally drafted by Pittsburgh out of the University of Minnesota, Frank Pietrangelo saw limited service with the Penguins over five seasons. He was traded to Hartford in a deadline deal in 1992 for a pair of draft picks, and he played strongly in the stretch run and playoffs. His 53-save performance in the Whalers' Game 7 double-overtime loss to Montreal was both the longest playoff game in team history and the last. (Courtesy of Carleton McDiarmid.)

RANDY LADOUCEUR. The six-foot-two-inch, 220-pound defenseman from Brockville, Ontario, began his career in the Red Wings organization. He came to Hartford in 1987 in a trade for Dave Barr and served as captain in the 1991–1992 season. Although he finished his career with Anaheim, he later returned to Hartford as an assistant coach. (Author's collection.)

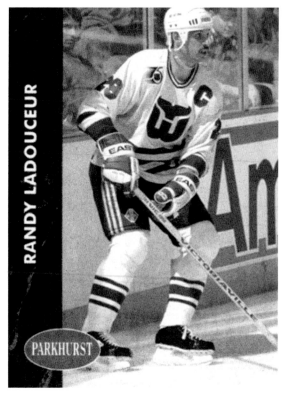

PAUL MACDERMID. Paul MacDermid got a taste of NHL action while still with the Windsor Spitfires, and it tasted good. A punishing checker who always seemed to be where he was needed, he split his playing time between Binghamton and Hartford before establishing himself as a full-time player in 1985–1986. Never a high scorer in the pros (his best NHL goal total was 20), he was the kind of hardworking, hard-playing, and, most of all, hard-hitting player that every winning team needs. (Courtesy of the Sports Museum.)

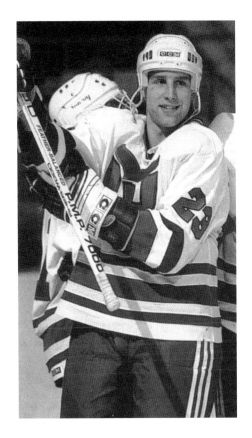

MARK HUNTER. Mark Hunter only played 74 games in two seasons with the Whalers, but he really earned his keep in the 1991 playoff series against Boston. He also played for Montreal, St. Louis, Washington, and Calgary, where he won a Stanley Cup in 1989. (Courtesy of Carleton McDiarmid.)

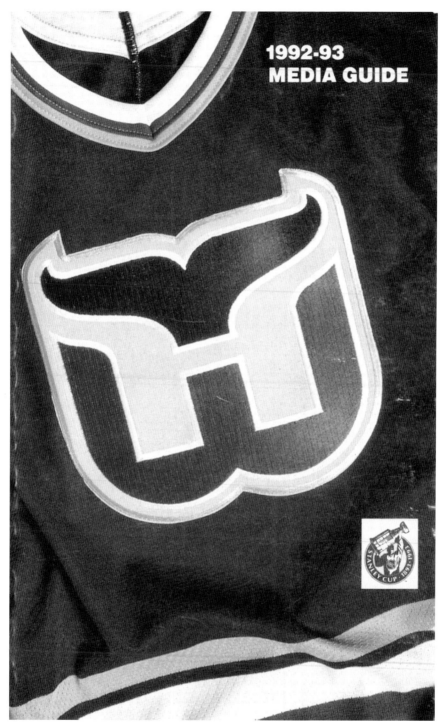

1992-93 MEDIA GUIDE

A NEW SEASON, A NEW LOOK. In 1992, the Whalers unveiled their new uniforms. For the first time in their history, green became a secondary color as the team switched to navy blue jerseys with green and silver trim. (Courtesy of the Sports Museum.)

DOUG HOUDA. No one ever accused Doug Houda of being shy about dropping the gloves. In fact, on one memorable night in 1992, he was assessed three minors, a major, and a game misconduct in a game against the Sabres, not a league record but a pretty good night nonetheless. Originally the property of the Red Wings, he spent much of his time in the minors, showing flashes of talent as well as flashes of fists. He was traded to Hartford for Doug Crossman in 1991 and in nearly four seasons with the Whalers played in 142 games. Dispatched to the Kings for Marc Potvin in 1993, he amassed 1,104 penalty minutes in 561 NHL games. (Courtesy of Matt Brady.)

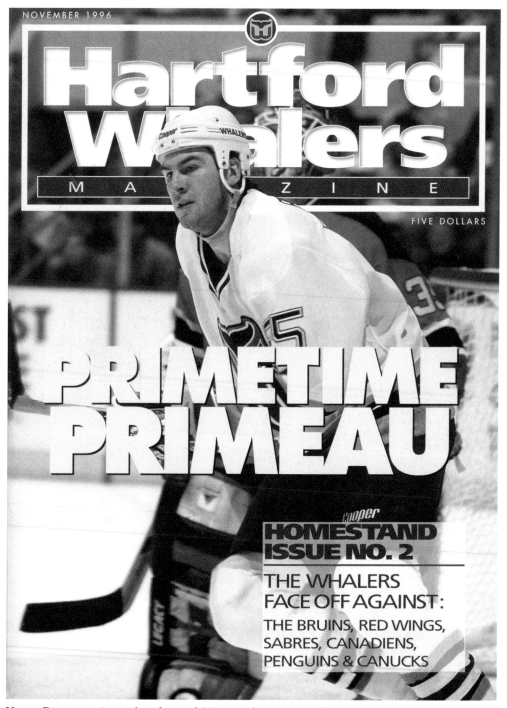

KEITH PRIMEAU. At six foot five and 210 pounds, center Keith Primeau was a force on the ice. Coming to Hartford in the Brendan Shanahan trade, he was able to get out of the shadows of Steve Yzerman and Sergei Federov and become a star in his own right. (Courtesy of Matt Brady.)

CHRIS PRONGER. The Whalers thought so highly of Chris Pronger's potential that they engineered a double draft pick trade to get him. Pronger struggled at first, and although he improved steadily, even making the NHL's all-rookie team, the Whalers decided to trade him. They dealt him to St. Louis for Brendan Shanahan. He later played for Edmonton and Anaheim, where he won a Stanley Cup in 2007. (Courtesy of Matt Brady.)

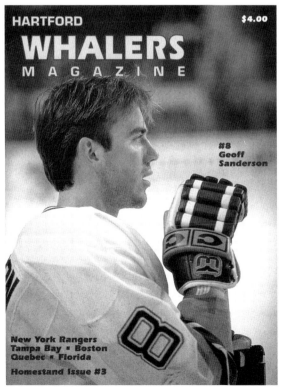

GEOFF SANDERSON. Drafted by the Whalers in 1990, Geoff Sanderson would move with the team to North Carolina. Along the way, the all-star winger was usually among the team's top scorers and was number one with 36 goals in its last season in Hartford. Possessing great speed, natural instinct, and puck-handling skills, Sanderson was one of the most versatile weapons in the Whalers' arsenal. (Courtesy of Matt Brady.)

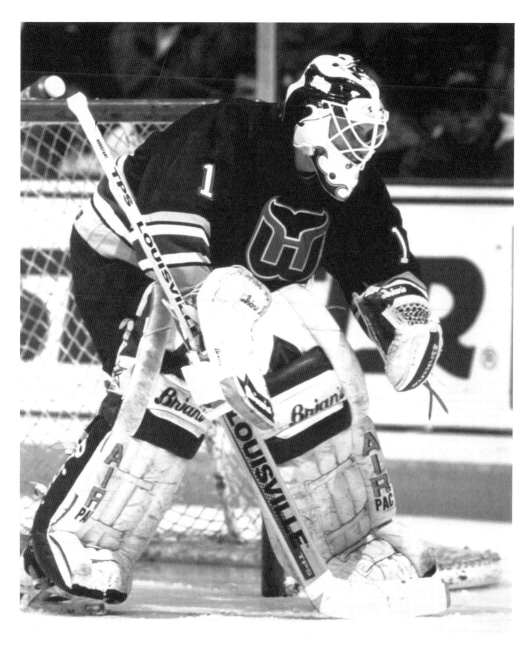

SEAN BURKE. Originally drafted by the New Jersey Devils, six-foot-four Sean Burke came to the Whalers in 1992 by way of a trade (with Eric Weinrich) for Bobby Holik and a pair of draft picks. Burke proved to be a workhorse in the net over his five seasons in Hartford. Moving to North Carolina with the club, he played for several other NHL teams over his long career. (Courtesy of John Bishop.)

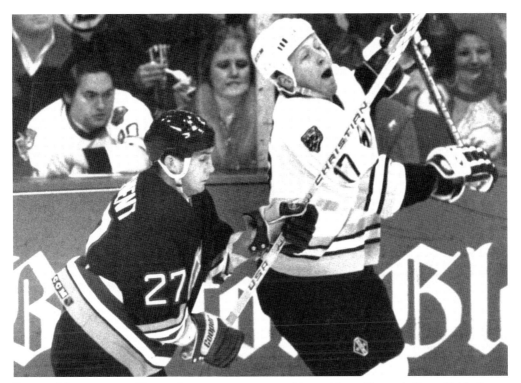

BRYAN MARCHMENT. Shown here giving a taste of his stick to Boston's Dave Reid, Bryan Marchment only played 42 games in one season in Hartford (1993–1994), but he was a throwback to an older style of hockey. He hit hard and played with a toughness at the blue line that made opposing players keep their heads up. (Courtesy of the Boston Herald.)

ADAM BURT. A stalwart at the blue line, Adam Burt was an offensive defenseman who was not afraid to use his size. He moved with the team to North Carolina, where he played for two seasons before being traded to Philadelphia. Burt and Andrew Cassals were the only members of the Hurricanes who had been with the Whalers when they played their last playoff series in 1992. (Courtesy of Matt Brady.)

GLEN WESLEY. Once a key member of the Bruins' defense corps, Glen Wesley was traded to Hartford for three first-round choices (1995, Kyle McLaren; 1996, Jonathan Aitken; and 1997, Sergei Samsonov). It was a high price, but one Hartford was willing to spend to get a player of Wesley's caliber. A member of the last Hartford team, he went to North Carolina, where he also played on the 2006 Stanley Cup–winning team. (Courtesy of the Boston Herald.)

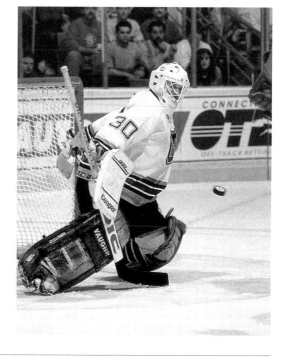

JEFF REESE. Perennial backup Jeff Reese played for several major- and minor-league clubs in his career. The Brantford, Ontario, native was drafted by the Maple Leafs in 1984 but spent much of his time with the Newmarket Saints of the AHL. He played three seasons in Hartford before being traded to the Tampa Bay Lightning in 1995. (Courtesy of John Bishop.)

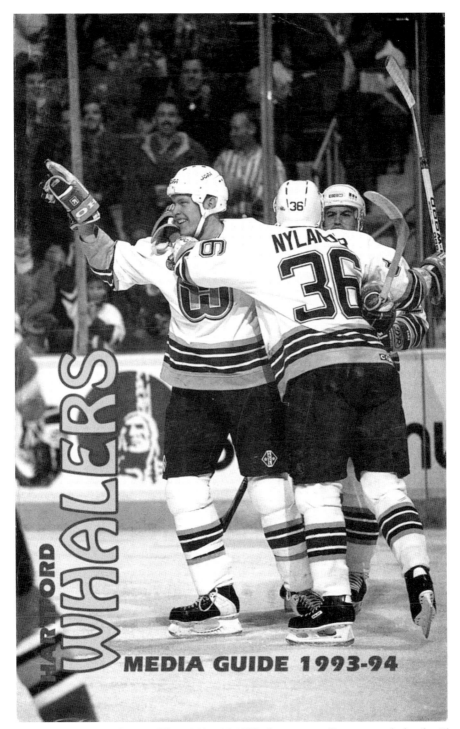

THE 1993–1994 MEDIA GUIDE. The 1993–1994 Whalers were still trying to shake the "forever 500s" doldrums. In June of the following year, the team would be sold to an ownership group headed by Compuware's Peter Karmanos. (Courtesy of the Sports Museum.)

Hartford Whalers
Zarley Zalapski

ZARLEY ZALAPSKI. Not to be confused with Merlin Malinowski, Zarley Zalapski came to the Whalers in the Ulf Samuelsson–Ron Francis trade. He was a member of the Canadian National Team from 1985 to 1988 and participated in the world hockey championships and Olympic Games during that time. He joined the Penguins after the 1988 Olympics and had a strong rookie season in 1988–1989. He was traded to Calgary late in 1994. (Courtesy of John Bishop.)

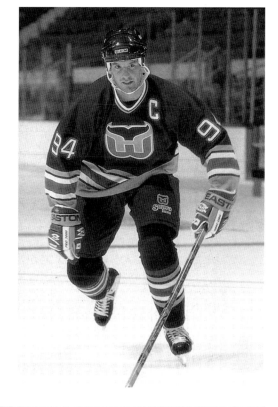

STAR-CROSSED. The Whalers thought they had the answer to their woes when they acquired Brendan Shanahan in 1995. But Shanahan struggled in Hartford and by the end of the season asked to be traded. He was sent to Detroit for Keith Primeau, Paul Coffey, and a draft pick. Primeau became a fan favorite and a leader on and off the ice, but the aging Coffey proved to be a disappointment and was eventually traded. (Courtesy of the Sports Museum.)

1994-95 HARTFORD WHALERS MEDIA GUIDE

THE 1994–1995 MEDIA GUIDE. By the 1994–1995 season, so many familiar faces were gone: Dave Tippett, Ray Ferraro, Ulf Samuelsson, Ron Francis, and Kevin Dineen. The Whalers pinned their hopes on rising stars such as Geoff Sanderson, Sean Burke, and Chris Pronger. (Courtesy of the Sports Museum.)

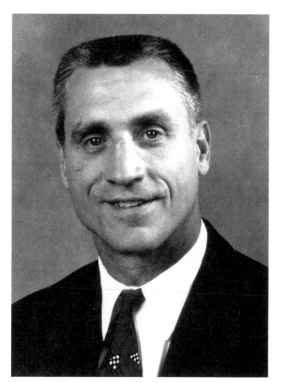

PAUL HOLMGREN. As coach and general manager of the Whalers from 1992 to 1995, Paul Holmgren set a standard that, unfortunately, his team could not achieve. As a player, Holmgren had been a tough, no-nonsense competitor with the Flyers of the "Broad Street Bullies" era. Even that could not prepare him for the situation in Hartford: meddling ownership, front-office shuffles, and a decided lack of talent. He was replaced by Paul Maurice in November 1995. (Courtesy of Matt Brady.)

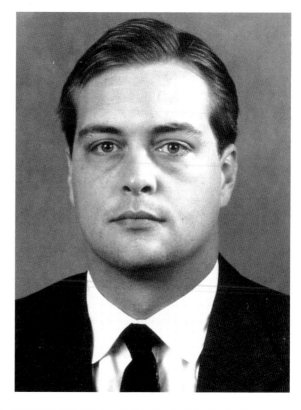

PAUL MAURICE. Paul Maurice was the last coach of the Hartford Whalers. Brought in to replace Paul Homgren in 1995, he was also the youngest coach in the team's history. After an injury forced him to abandon his hopes of a professional career, he turned to coaching, working his way up the ranks. He was behind the bench for the last game, the 2-1 win over Tampa Bay on April 13, 1997. (Courtesy of Matt Brady.)

THE NHL

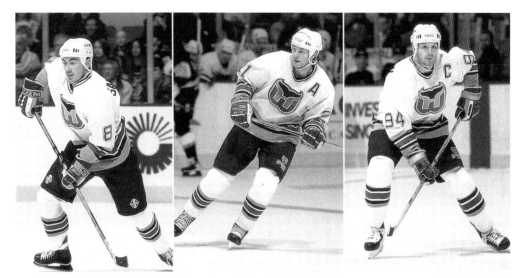

THE SCORING LEADERS. Seen here from left to right, Geoff Sanderson, Andrew Cassels, and Brendan Shanahan did a lot of lamplighting in the 1995–1996 season. (Courtesy of Matt Brady.)

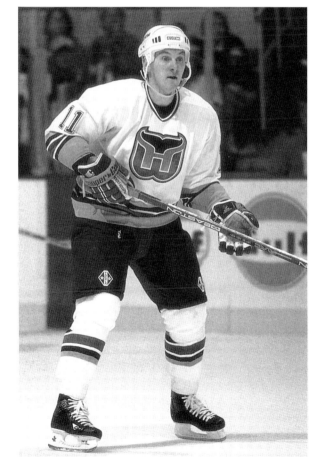

ANDRE NIKOLISHIN. Like the great World War II sniper Vassili Zaitsev, Andre Nikolishin hailed from the cold Ural Mountain region of Russia. A product of the highly disciplined Soviet hockey system, he was a skilled marksman who played for the aptly named Moscow Dynamo and captained the Soviet National Team at the tender age of 21. (Courtesy of John Bishop.)

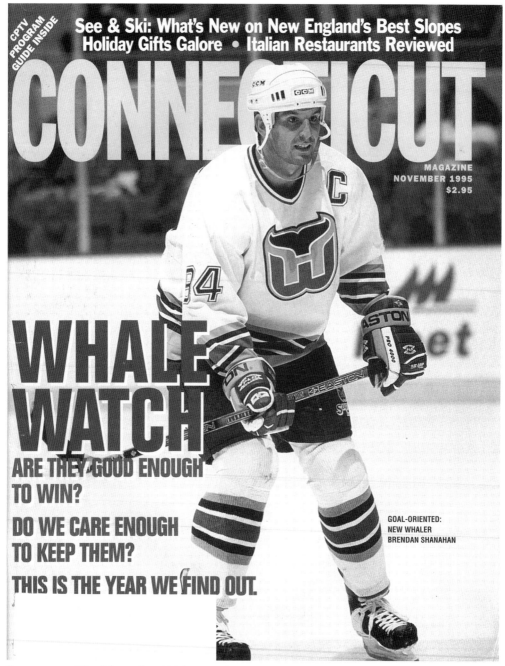

On cover:
CPTV PROGRAM GUIDE INSIDE

See & Ski: What's New on New England's Best Slopes
Holiday Gifts Galore • Italian Restaurants Reviewed

CONNECTICUT

MAGAZINE
NOVEMBER 1995
$2.95

WHALE WATCH

ARE THEY GOOD ENOUGH TO WIN?

DO WE CARE ENOUGH TO KEEP THEM?

THIS IS THE YEAR WE FIND OUT.

GOAL-ORIENTED:
NEW WHALER
BRENDAN SHANAHAN

RUMBLINGS. This November 1995 issue of *Connecticut Magazine* asks the questions "Are They Good Enough to Win?" and "Do We Care Enough to Keep Them?" The fans would say yes, but the fact that the questions were being asked was enough to cause concern. (Courtesy of John Bishop.)

4

DEPARTURE

While the team had strong fan support, Hartford was considered too small a market and its arena too small a venue to generate the revenues needed to keep an NHL franchise going. In 1994, a new ownership group led by Peter Karmanos purchased the Whalers for $47.5 million. Although Karmanos, the founder of the enormously successful company Compuware, pledged to keep the team in Hartford, negotiations to build a new arena and other benefits to the team broke down, and eventually the team announced that it would leave Hartford. It chose Raleigh, North Carolina, where it was to be known as the Hurricanes, starting in the 1997–1998 season. While the fans of the Whalers were heartbroken, the success that had eluded the team in Hartford was finally achieved: in 2006, the team won the Stanley Cup. Many Whaler fans traveled to North Carolina to watch the games, many sporting their old sweaters, green and blue with the *HW* whale tail crest. The team may have moved, but for the Hartford faithful it still was, and would always be, the Whalers.

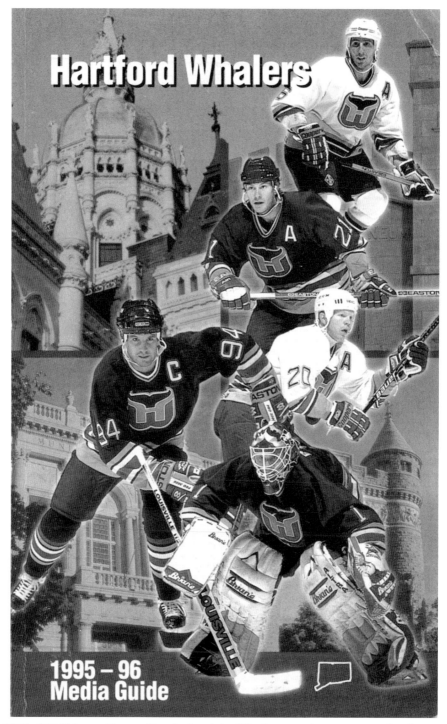

THE 1995–1996 MEDIA GUIDE. Hartford and the Whalers—at this point it was hard to imagine one without the other. They were inseparable, part of each other's identity. Sadly, it was not to be. (Courtesy of the Sports Museum.)

PETER KARMANOS. Compuware executive Peter Karmanos, along with Jim Rutherford and Thomas Thewes, formed KTR Hockey Limited Partnership and purchased the Whalers. As CEO and governor of the team, Karmanos is the man most Whaler fans blame for the team's move to North Carolina. (Right, courtesy of Matt Brady; below, courtesy of the Sports Museum.)

THE LAST CAPTAIN. Kevin Dineen was a Hartford third-round draft pick in 1982 and during his rookie year (1984–1985) scored an impressive 25 goals. One of the team's leading scorers throughout the 1980s, he was traded to Philadelphia in 1991 but returned to Hartford in 1995. He was named captain, a position he held with the Hurricanes, making him the Whalers' last captain and the Hurricanes' first. (Courtesy of the Sports Museum.)

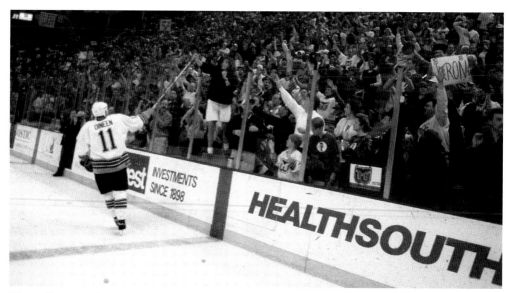

KEVIN DINEEN GIVES HIS STICK. Several lucky fans received souvenirs from the players after the final game. (Photograph by Tom Brown; courtesy of the Hartford Courant.)

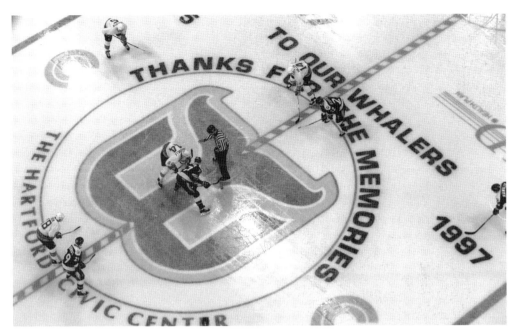

THE FINAL GAME. On April 13, 1997, the Whalers played their final game. Captain Kevin Dineen scored the game winner as they defeated the Tampa Bay Lightning 2-1, but it was an empty victory. (Photograph by John Clark Russ; courtesy of the Hartford Courant.)

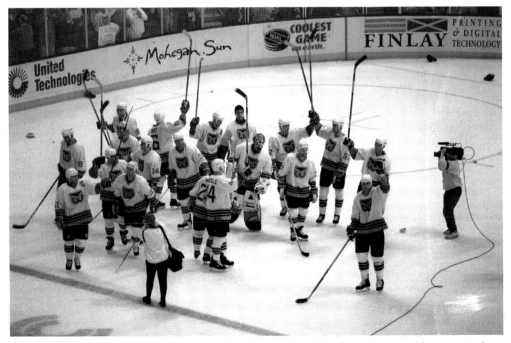

PLAYERS SALUTE FANS. After the game, the players saluted the fans to express their gratitude to the faithful of Hartford who had supported them for so long. (Photograph by John Clark Russ; courtesy of the Hartford Courant.)

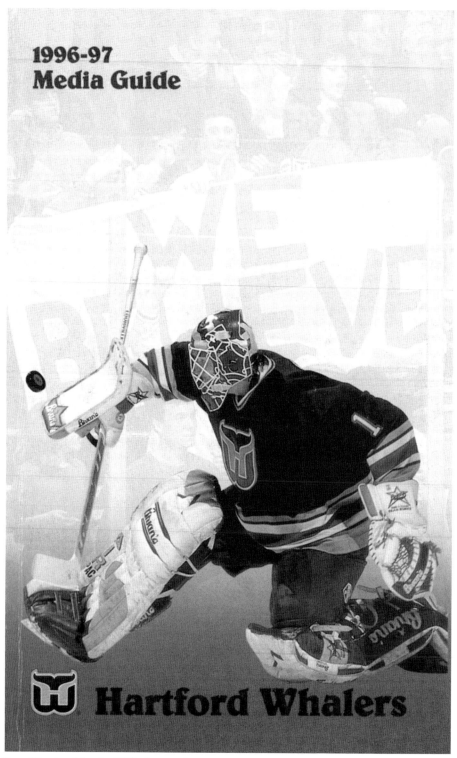

1996-97
Media Guide

Hartford Whalers

AN END. The last Hartford Whalers media guide appears here. (Courtesy of the Sports Museum.)

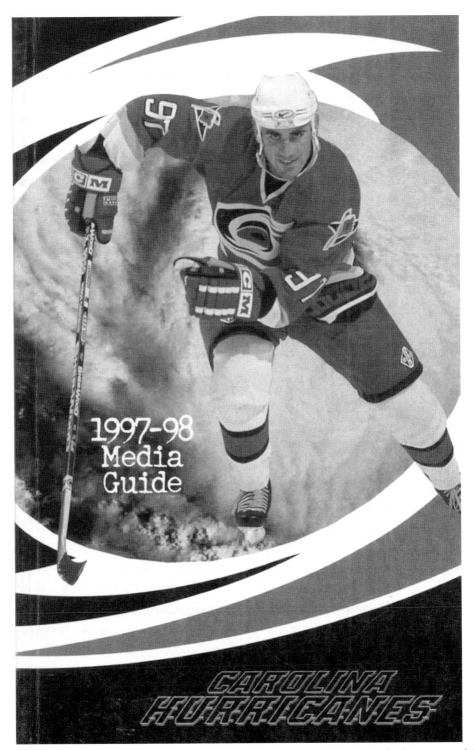

AND A BEGINNING. Shown here is the first Carolina Hurricanes media guide. (Courtesy of the Sports Museum.)

GONE BUT NOT FORGOTTEN. The Whalers may have abandoned Hartford for greener pastures, but Whalermania has been passed along to a new generation of fans. (Courtesy of Will and Amy Brother.)

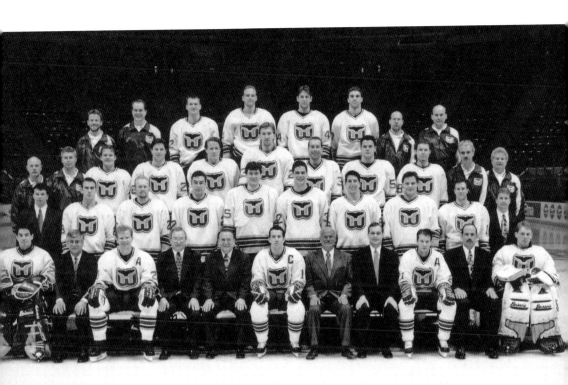

THE LAST TEAM. Pictured here, from left to right, are (first row) Jason Muzzatti, assistant coach Tom Webster, Glen Wesley, vice president of hockey operations Terry McDonnel, president/general manager Jim Rutherford, Kevin Dineen, CEO/NHL Board of Governors Peter Karmanos, head coach Paul Maurice, Andrew Cassels, assistant coach Randy Ladouceur, and Sean Burke; (second row) assistant coach Steve Weeks, Geoff Sanderson, Derek King, Jeff Brown, Keith Primeau, Stu Grimson, Adam Burt, Curtis Leschyshyn, Nelson Emerson, and director of public relations Chris Brown; (third row) medical trainer Bud Gouveia, assistant equipment manager Bob Gorman, Sami Kapanen, Paul Ranheim, Steve Rice, Marek Malik, Steve Chiasson, Alexander Godynyuk, Robert Kron, equipment manager Skip Cunningham, and equipment manager Wally Takomir; (fourth row) massage therapist Dave Duffy, assistant equipment manager Rick Szuber, Jeff O'Neill, Kevin Haller, Kent Manderville, Chris Murray, strength coach A. J. Ricciuti, and strength coach Peter Friesen. (Courtesy of Matt Brady.)

ACROSS AMERICA, PEOPLE ARE DISCOVERING SOMETHING WONDERFUL. THEIR HERITAGE.

Arcadia Publishing is the leading local history publisher in the United States. With more than 3,000 titles in print and hundreds of new titles released every year, Arcadia has extensive specialized experience chronicling the history of communities and celebrating America's hidden stories, bringing to life the people, places, and events from the past. To discover the history of other communities across the nation, please visit:

www.arcadiapublishing.com

Customized search tools allow you to find regional history books about the town where you grew up, the cities where your friends and family live, the town where your parents met, or even that retirement spot you've been dreaming about.